The stories in this book touch on w[...]
producer and director of youth theater over the last 45
years. Photographs, original writings, excerpts from
plays performed over the years, grade school art given to
us in thanks, junior high school kids raw art created in
the junk art class enhance these memoirs. Inspired by
the season of love in the 1970's, This love technique,
has proven itself to be a life changing way of doing
theater; a free form creatively artistic, all inclusive,
theatrical experience. Thousands of kids and adults
have joined with us to help develop this process that
includes … how shall I put it… this process includes you
and what you have to offer. Because what could
possibly be more exciting to everyone involved then
including you with your thoughts and your actions and
your spirited ways. You my friend are an original… a one
of a kind… a very special experience to be had. We feel
blessed to have you with us and we can't wait to see
what unfolds what treasures you are willing to share.

THIS IS AN ALL-INCLUSIVE FREE RIDE INTO THE
DRAMA OF EXPRESSION
You are one of a kind yet to behold.

Hello everyone.
My name is Peter James Ljung.
It is a honor to be asked to do this foreword for Eric.
I have known Eric only a short period of time. (October 2018)
Just recently, Eric had mentioned a few things to me about a 40-year adventure in Theater and production. Of course, I was really interested as I am an author.
He wanted so much to be able to get peoples opinion's on his 40-year memories, with pictures and artwork as well as scraps of paper that had been written on.
When I agreed to take a look at the project.
Wow! Was I blown away with the first few emails containing some of the project. I had no hesitation in telling him I would gladly help in putting the book together.
Then file after file arrived on my computer. What I saw was this!
I saw a dedicated man put his life and soul into something he believed in strongly.
Working with youngsters from all ages. Some pictures in this book tell a story that some words could not. What I saw was innocent's and a magical aura beaming from each page I opened.
As you turn each page, you will be sucked into the pictures and words of a child, or a mind that loves to help children of all ages.
Eric has given me permission to mention his dyslexia. That is raw courage in itself. To admit that you have problems with stuff when you are young is one thing, but to admit that you had this problem as an adult takes pure guts. I know the amount of work Eric has put into this project with blood sweat and tears.
When I talk to Eric on the phone as I am in Sweden. I hear a man who is gentle and talks from the heart, who loves life and the people around him.
He is a gentle man.
I hope you, like me, will see the beauty in all his work that has spanned a 40-year period.
Please sit back and enjoy.
TEENAGE MUTANT THEATER

Now!
On With
THE SHOW

IF ONLY I spelled
Right drew
properly saved
money didn't get
FAT. Played my
CARDs right

I LIKE when we doew the
plas.

KID'S ART

I like when we do the plays

FORWARD

Student Raw Art

In this book you will see

Student Raw Art

From the walls of this classroom

ANARCHY JUNK art
VENUE FOR ANARCY
IN during PUBERTY
A CLASS FOR young
PEOPLE TO discuss

OPENLY and with
NEW NOTHING UNallowed
SINCE ART → THE ART
EXpression comes FROM
THE INNER SELF
How can it EMERGE
FROM The INDividual
IF AS A TEACHER
I TRY TO CONTROL
OR ORDER The External
world

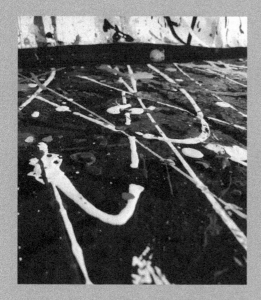

Kids Art

You will also see Kids Art by 4 to 10 -year-olds
inspired by the plays they were in.

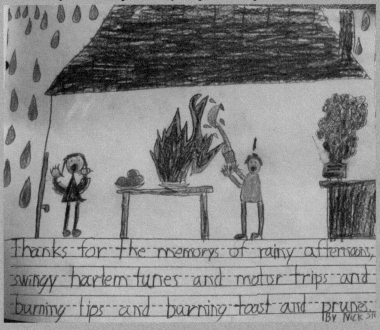

KIDS ART

'A young person drew this picture that is inspired by a song Maureen had the kids sing
'Thanks for the Memories' in the play Bremen Town Musicians - 2014'

Photos from plays

Random play photos found in drawers and boxes

SUMMER STOCK CAMP OUT AT SAGE HILL – SUMMER -1996

NUMBER FOUR

At times AS I
Express myself on
the PAPER I USE TO
ORiginate all my
MEMOiRS I FEEL THE
ORiginal coPy IS WORTH
SHowiNG cause IT
expresses my desire
my HUNGER
my LOVE OF you
dEAR READER
So you Too FEEL
THE HURRICANE OF
my JuICE
THAT WHICH IS ME.

PROLOG

WHAT DO YOU WANT TO BE? HMMMM SO YOU WANT TO BE A STAR WITH THE MOST LINES

What do you want to be? Hmmmm? So you want to be a star, with the most lines.

Okay…. and

you're asking me
witch part is
the biggEST..???
WHICH Part has
THE MOST LINES?

No really, you can have as many lines as you want.

Back in time
To 1968
OH WHAT FUN
WE ARE doing
ROMEO and JULET

Eric Lehman gets the part of the Prince's

3rd gaurd

I did get some direction.
Director tells me;

" STOp moving your eyes dont watch The action !!!

Be perfectly still!

So THE NEXT yEAR
WE WERE allowed To
MAKE OuR OwN
SHOw and WE WERE
Having a grand TIME
UNTIL

As we show our teacher the first run-through of our show,
we were laughing and shouting and cheering.....
and he said;

!you Need To Take

THIS Process more

seriously " " All

This NOISE ~~your~~

and goofing arou

will get you

NO where.....

STUDENT RAW PERFORMANCE ART

"You need to take this process more seriously. All this noise and goofing around will get you nowhere…."

A 'professional', from Hollywood, came to visit our high school, and, told us during a mini lecture tour about working in show biz. "If you want to be in the movies you have to do whatever it takes

ITS NOT FUN ItS woRk"

Not fun?!?!?
It's work in Hollywood?
Not too groovy.
My direction in Romeo and Juliet -
"Don't Move!" - Good God man!
Don't goof off while
 creating new work? Holy Cow!

STUDENT RAW ART
'So we did plays in a new style.'

This brings me to...... 1973.

NO ONE Had done These kind of PLAYS BEFORE

And this whole bologna of one person having many lines and the others none.

"Just dont move!!" was NOT gonna happen. So PLAY WE did in a new style To This

? LEAd

I want a Lead and a Lead MAY NOT BE The answer To your Needs

The real power
is in the hands of the actor
to make their part grand.

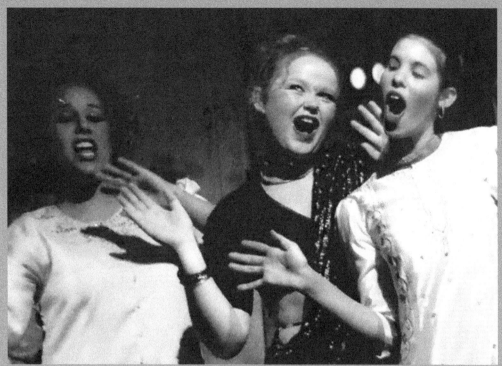

BEAUTY AND THE BEAST - 2005 –

ACT I

FIDDLER ON THE ROOF -1997
'So play we did in a new style'

LEGEND – 2013
'A lead may not be the answer to your needs'

"That was the Beginning OF ONE HELL OF a good run of plays where the kids at Free School created and rehearsed a play in the morning and put it on in the afternoon for the teachers and parents and kids who were too young to be swinging from trees and jumping in ponds or throwing garbage at the Man Bat… All part of the traveling show where the audience was directed to follow the play into the canyon……."

PREVIEW OF 1973

- Nixon on national TV, accepts responsibility, but not blame, for Watergate; accepts resignations of H. R. Haldeman and John D. Ehrlichman, fires John W. Dean III as counsel (April 30).
- Spiro T. Agnew resigns as Vice President and then pleads no contest to charges of evasion of income taxes while Governor of Maryland (Oct. 10).
- In the "Saturday Night Massacre," Nixon fires special Watergate prosecutor Archibald Cox and Deputy Attorney General William D. Ruckelshaus; Attorney General Elliot L. Richardson resigns (Oct. 20).
- US Supreme Court rules on Roe v. Wade.
- Popular Musicians and songs
- Stevie Wonder
- ABBA
- The Eagles
- John Lennon
- Paul Simon
- Pink Floyd " Dark Side Of The Moon "
- Rod Stewart
- Michael Jackson
- Elton John with " Crocodile Rock "
- Rolling Stones with " Angie "
- The Moody Blues
- David Bowie
- Led Zeppelin
- Paul McCartney and Wings with " My Love "

Popular TV Programmes
- The Odd Couple
- The Partridge Family
- Columbo
- Masterpiece Theatre
- McMillan and Wife
- M*A*S*H
- Sanford and Son

- The Bob Newhart Show
- The Price Is Right
- The Waltons

Popular Films

- The Exorcist
- Deliverance
- Live and Let Die
- Paper Moon

- Dark Side Of The Moon Reminded by Pink Floyd Fan
- Last Tango in Paris
- Jesus Christ Superstar
- American Graffiti
- Lady Sings the Blues
- The Sting

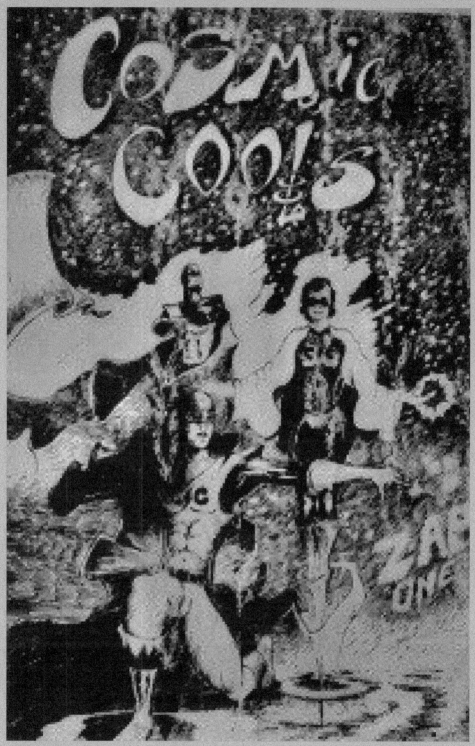

COSMIC COOLS - 2001
poster by Ben Hazard

OH SURE IT COMES
AND IT
GOES
BUT WHAT THE HECK
ONE-DAY-PLAYS AT THE
MONTESSORI SCHOOL
1973

OH SURE IT COMES AND IT GOES BUT WHAT THE HECK.....

If ya can't count on it showing up when you want it to you just might as well get a real job washing dishes or get into the brain sciences...

The muse.
That which shows up randomly, sporadically, not necessarily when you want it to. That little ball of energy that thrills the very existence. Hits you excitedly at the core of your being.
Ah yes.

I myself have tasted the forbidden fruit sitting at my place in the coffee shop letting loose the words onto the note pad word after word surprising me with its apt structure and the wonder of all wonders,
I feel it,
I feel it.

Am I just writing about this moment in time that I believe in? What I wrote, what happened to me back there; Oh hello, I'm Eric Lehman. I would like to volunteer here at your school.

The Montessori School, then up on the S.B. Riviera. I was 19 years old and ready for action.

"Please let me help out here "
"Oh sure you can help out. But what can you do?"

"I can do plays with kids."

[a side note; I had never done plays with kids in my short life but something in me just jumped into the fray.]

"when?"

"Now. Yes now on the playground. I will do a play with them or you can just count me out."

So, play in the morning. All talking at once. How to approach the masses and make sense of them. What indeed?

The primal core of expression was somehow going to devest itself onto me, onto them, and we would start acting together.

Ahhh but how?

"Will you be in a play?
Can you be the most exciting part in the world?
Would you play the woodrat trying to get into a house by gnawing at the wood on the siding day after day finally achieving your end by ceaseless activity.

"I want to be this!"

"Who wants to be bad? Who wants to be good?"

And kids …..we are going to have…… SOME SUPER
HEROES IN EVERY SHOW!

We do
They're called the Cosmic Cools!

"Really what do they do?"

"They save the day using their secret powers!
Mr. and Mrs. Cha-Cha-Cha will be the troublemakers."

"YOU!"
"Who me?"
"Yea you! Can you be really really crazy and fall down?
Act like you are in pain, then get up…… and this is when
the crazy…."

"What is really gonna happen is this….!!!"

"You over there with the blue shirt! You are all nice. And so
you're the good."

"You're the bad. And you're the innocent."

Truth be told I could go to my schools and put on one day shows for quite a while.

Everyone got involved. We would do plays in the mountains, and kids would fall in the water, and deliver their lines, with makeup that was dripping.

Shouts of; "Help me!"

Scores of kids running from rock to rock. The performance must go on! Nothing could stop us!

Untaught rebels couldn't, wouldn't, be restrained… restrained.

No. On I would go. One day after the next. With no idea! Until…… we would go around the circle……and…..

I would coax the ideas from the little people's minds.

"Hey what do you want to be?"

"A soldier of fortune!"

"A good guy or bad?"

"What kind of story? Mystery, funny, science fiction, fairy tale?"

The show must go on!

"So, yes... You have your hand up what do you want to say?"

"Can we stop talking and do the play!!!!"

"Okay! You run and hide! In fact all of you hide when he jumps out! You jump out…. And then you realize what is really going to happen!"

Is from the cuff. In the moment. Fresh as a daisy. It spouts out of my mouth, or yours.

And, from action comes results.

And in the end…. A magician would come from a TV.

And,
a force
of ridiculous circumstances.
With only one remedy!

THE COSMIC COOLS TO THE RESCUE!

And it wouldn't end there.
Inevitably the Cosmic Cools
Would be forced, compromised, sacrificed. And there

would be only one thing left possible.......

The news reporter said it perfectly.

"Is all Lost?!?!?!"

"Is all Lost?!?!?!"

And the ..
the......
news reporter was compromised!

To be forced into being a pollywog!!!!

Or dancing the Cha Cha Cha!!!

Or perhaps......

Spooked by the horrifying spooks in the play Midnight Darkness!!!

When all is said and done, play after play that year. Play after play would unfold.

One new one. Week after week. Day after day.
And life time after life time.

Because no matter who died, they would always come back to life.

Healing properties of the Cosmic Cools ZAAAPPPP!

Or the decisions by The Strange Magician, who could no more justify his overbearingly, all encompassing, forced reality. And all because he hated T.V.

Ruining lives, destroying families

"But no more! I see the errors of my way!"

So all would indeed be good in the end. And the morals of the stories would be so absurdly played as to leave you happy and laughing.

And what more is there to life then joy and mirth? And don't go spouting about hard work gets results. No I don't want to hear it.

All hard work means is the you're confused dancing with frivolity. And forced labor has become your tool to teach. And what are you teaching?

Versus

What does the arts teach?
"Oh heck get off it! Get off your high horse and lets just dance a little while we study the realistic ways of the world. Without which we would not have water or soap to wash our hands and the pencils to draw with.

All I ask is, treat me well. Treat me like a human, with dignity. Treat me well please. Like someone who knows something. Please give me the benefit of the doubt. After all I'm only a kid.

And what you think
I need to know.....
is.....
all
that you
want to give me!

Share a dream. And lets go sliding down the Slippin' Slide.

And come on!
COME ON! IT CAN'T BE THAT HARD TO DANCE THE CHA-CHA-CHA.

And that's when it starts…..Cha-cha…….Cha-cha-cha

The TV announcer: "Oh no! The whole town! The whole city!!! The whole country!! Even the president! Everyone's doing the cha-cha-cha!

Up come Mr. and Mrs. Cha Cha Cha.

ANOUNCER: "Is all lost???"

Mr Cha-Cha: "Hey you! You ever dance the cha-cha-cha?"

Mrs Cha Cha: "It's fun!"

TV announcer: HEEEELLLLLLPPPPPP! Cha-cha….. Cha-cha-cha…. Cha-cha….. Cha-cha-cha…. Cha-cha….. Cha-cha-cha….

COSMIC COOL ONE TO THE RESQUE!!!
ZAPPPPPPP ONE!!!!

COSMIC COOL 2 TO THE RESCUE
ZAAAPPPP TWO

COMSIC COOL 3 TO THE RESQUE
ZAAAPPP THREE

ANOUNCER: The world is coming back to normal
 How can we ever thank you Cosmic Cools?

 COSMIC COOLS:
 You can help us

 By helping yourselves!

THIS WAS
THE
BEGINNING
OF MY
ADULT
LIFE

(1973 – FREE SCHOOL)

THIS WAS THE BEGINNING OF MY ADULT LIFE

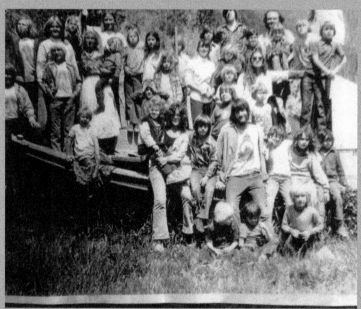

1973 -BigE at the Free School with the kids and teachers in Corbalini Canyon
"it had a dream like quality as though I'd been there before".

I was walking down the steep road into Corbalini Canyon.
It had a dream like quality
as though I'd been there before.
In fact

the dreams

I had been having for nights before this very day

seemed to me......
that.....
they were indeed

of this very place.

In my dream
I jumped and glided into the Canyon.
 Around me were very familiar and loving people.

They were so glad I
made it.

STUDENT RAW ART
'I could feel it cursing through the very fiber of my being.'

It felt so right.

Now as I walked into the school yard,
in this shaded canyon,
with lovely trees,

I felt I had
arrived.

I had that feeling
that I had arrived.

I could feel it cursing through the very fiber of
my being.

I believe now this dream was prescient…..

pre·scient

1. having or showing knowledge of events before they take place.

…prescient of the artistic endeavors I would be acting out for the next 45 plus years.

It was no mistake that this dream

came to me

at this time

to inaugurate the beginning

of my life's work.

As I walked down into the canyon
the echo of children's voices rang in my ears

And

I knew

I was in the right place
to start yet another
young actor's company
that would put on plays
in one day,
once every week.

The Free School was quite different
from the Montessori Center School
across town where I had already
started directing plays.

I walked up to the throng of young
students and young teachers.

This was

the Free
School.

There was a lot of talk and chatter.
And **NO** groups of kids
sitting in classrooms.

In fact ……………………………………

there seemed
to be
many things going on at once.

Everyone
seemed to be
doing their own thing.

A little teaching
one on one
here and there
from different teachers to students.

However it did seem like chaos reigned.

This group of unruly unkempt hippy kids
were going to be......

my new actors!

BigE -1974
'no groups of kids sitting in classrooms. In fact there
seemed to be many things going on at once.'

Wizard of Oz 1974
'This group of unruly unkempt hippy kids, were going to be my new actors'

AW IT SEEMS LIKE A TIME OUT OF REALITY

STUDENT RAW ART

(1973 *GIANT MAN BAT*)

GENIE AND THE MAJIC ORB / 1974

STUDENT RAW ART

Life is weird
~~Writing is weird~~
Words are weird

You almost always never experience
what you think you will

What is weird?

AW IT SEEMS LIKE A TIME OUT OF REALITY.

How in God's name
could these shows
really come down to earth?

And played out,
their mission,
right here in front of you.

1973

You may not have been alive
the steamy warm May day when a truly
exquisite story
played out
for the wild and free parents and kids
then in Corbalini canyon.

STUDENT RAW ART
'come down to earth and played out their mission'

The Man
Bat

The Man Bat

The Giant Man Bat.

Play in 5 different locations,

Up and down the beautiful canyon,

Ending in a small quarry....
where....

when the audience arrived,
circling on the cliffs,
surrounding the quarry,

were boxes of

garbage!

'Because they were to be thrown'

We had collected
earlier in the day
from behind a
grocers.

old fruit and vegetables only

Because
they were to be

thrown
the Giant Man Bat.
at

Which is why we had constructed his giant wings,
out of sturdy cardboard,

with feathers glued on a perfect shield against
the fruit.

A veggie

on-slodge.

on-slodge
noun
An onslaught of crushable items that hit and disperse
'an on-slodge of waves hammered the poor boy'

But I have jumped ahead.

What about

Jarvis and Darbo?

Well....
They had been approached

STUDENT RAW ART

'What about Jarvis and Darbo?'

were upset

because

a Man-bat

had come to their village
and
was a GREAT THREAT!!!!

It was a giant Man-Bat!

So Jarvis, played by Dana,

STUDENT RAW ART – paint on carboard
'A Man-Bat had come to their villiage'

and
Darbo played by
Turk,

'followed the trail and had one battle after another'

STUDENT RAW ART

'the Indians were deeply threatened and harassed'

village

where
the Indians
were deeply
threatened and harassed.

(Many kids
thrown this
way and
that)

Lots of upset!

Every Indian had something to say.

Jarvis and Darbo had

a plan.

They got everyone involved.

The audience wasn't on the edge of their seats, because, the
sitting was on the ground

Jarvis and Darbo had

a plan.

They got everyone involved.
The audience wasn't on the edge of their seats,
because, the sitting was on the ground,

As Jarvis and Darbo
lead the Indians
in corralling

the Man

Bat

into the

grotto,

the quarry,
the cliffs,

where the audience ended up.

STUDENT RAW ART
The audience wasn't on the edge of their seats
because the sitting was on the ground. But mostly
running after the actors

Was also lined with boxes

filled with old fruit and veggies.

The Indians shouted out
to the audience;

"Help us get rid of the Man Bat!"

STUDENT RAW ART
'Which is when the audience Seeing the
Indians start to pelt me'

STUDENT RAW ART
"Help us get rid of the Man-Bat!"

Which is when, the audience,
Seeing the
Indians
start to

pelt

me,
(I was the Giant Man Bat) with
produce!

"LOOK!!!"

shouts out Darbo

The Medicine Chief:

"It's a Wom-bat and it's BAY-BAT!

And sure enough,
from the far end of the quarry,

dances
Dana and Turks's sister (Heidi).

STUDENT RAW ART
"LOOK!!!" shouts out Darbo The Medican Chief;
"It's a Wom-bat

And sure enough,
from the far end of the quarry,

dances
Dana and Turks's sister (Heidi).

Heidi the

Wom-bat

dressed with big wings
similar to mine
she is holding a baby,

and
in her arms.

STUDENT RAW ART
'Hiedi the Wom-bat dressed with big wings
similar to mine'

_aBay-bat,

her baby sister
(Sophie) in real life,

Who.. yes has wings!

All I can say is
we went off into the sunset together.

You could hear the Indian wise woman say;

46

STUDENT RAW ART

'All I can say is we went off into the sunset together'

"There was nothing to be afraid of after all. It was only trying to find food for it's young."

STUDENT RAW ART

'You could hear the Indian wise woman say; "There was nothing to be afraid of..."'

A GOOD PLAY
IS NOT
ARRIVED AT
FROM LOOKING
IN THE
LIBRARY

(1975 - MERMAIDS TALE THE STORY OF JOHN)

A GOOD PLAY
IS NOT
ARRIVED AT

FROM

LOOKING IN THE
LIBRARY.
Oh gosh no.

Just as
a good piece of art
is not a required outcome
of plain
pen to paper.

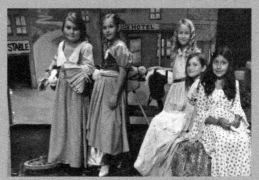

Destry Rides Again - 2009 –
'the play is on and only nothing can stop it'

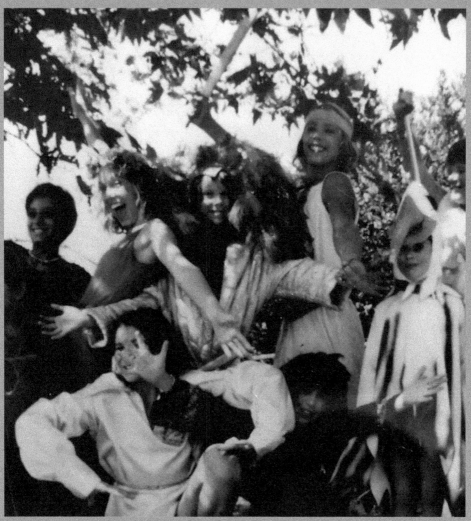

Voyage of the Dawn Treader -1975
'When doing a play First bring in the clowns Show them the idea'

When doing a play…
First
bring in the clowns.
Show them
the idea.

The play is on!
And, only nothing
can stop it!

Shall I tell you
the tale of the mermaid

How it is
her,
in her silence,
that
unearths
the shallow inhumanity

of a surface movie star,

prince,
in modern times.

Stop telling us the
renegades

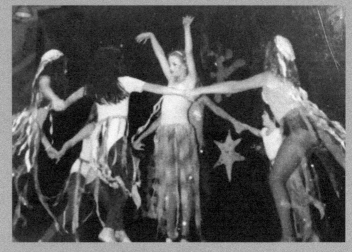

MERMAID'S TALE – 1978

'How it is her, in her silence, that unearths the shallow inhumanity of
a surface movie star, prince, in modern times."

that the Disney story,
the story told
through
a lovely Idyllic
setting,

a formula of story
telling
that makes
America
what it is
on its lowest level!

$ from all

to see the safe and
sound.

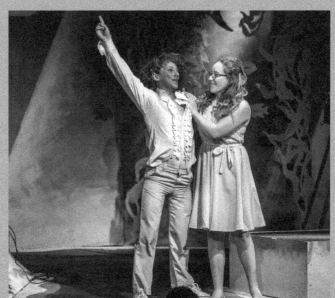

MERMAID'S TALE – 2017

'A formula of story-telling that makes America what it is on its lowest level.

$ from all to see the safe and sound.'

"YOU YOU are talented!"

"I'll take you in
and teach you
where to stand,

and,

what's required."

"You are a star!

You are better then the rest."

Therefore

Dracula Teenage Fantasy –
1979 –
'You're so good…. Oh everyone
thinks so'

STUDENT RAW ART
'And what's required You are a
star You are better then the
rest'

whats the point of me when shes everything everything i am, and more?

STUDENT RAW ART
'And what's required You are a star
You are better then the rest'

I will pay you heed.

Yes

I

love you because you have talent!
You're so good …… Oh everyone
thinks so!
What if you

MAKE IT TO HOLLYWOOD AND BECOME A STAR THEN EVERYONE WILL LOVE YOU

Again I say;

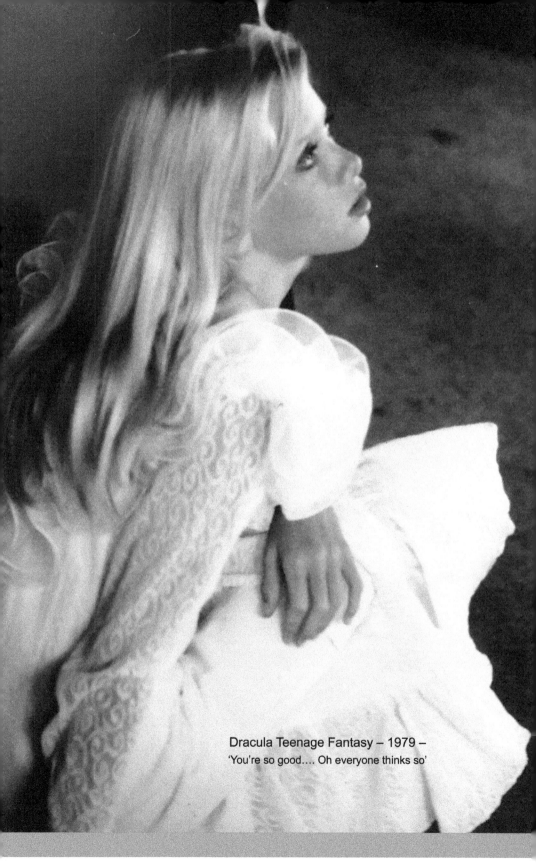

Dracula Teenage Fantasy – 1979 –
'You're so good…. Oh everyone thinks so'

NO NO NO

PLEASE

We are not robots who can only paste
premade things
In designated places!

WHAT IF

JUST THIS ONCE

you.....

Hey you
wild child,
renegade,
especially weird,
odd,

or

Lord Of The Rings -1991

'Hey you wild child Renegade especially weird Odd'

STUDENT RAW ART

'you are spontaneous'

JUST NOT INTO
BEING ONE OF
THOSE

ONE OF THOSE
FOLKS WHO IS ONLY
SATISFIED WITH
SAFE STUFF EVERY
ONE KNOWS IS GOOD

Just what if you are a funny person.

And…

Not yet……

NOT …..

YET….

nooooo.

NO …….

Yes.

There she blows!

Funny!

We love you
because you are spontaneous.
And, everyone here fits
 in their own way.

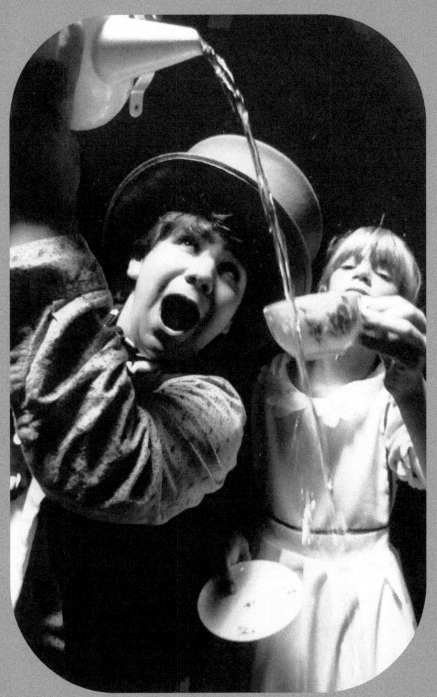

ALICE IN WONDERLAND – 1987 'And, everyone here fits in their own way

'Echoed by the hideous Leach "Turn to sea foam! Turn to sea foam! You shall surely turn to sea foam!"'

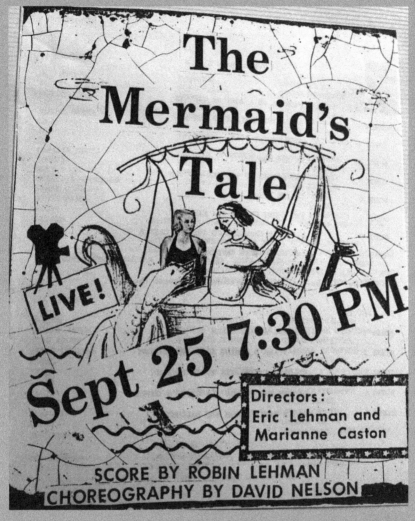

POSTER BY FREDDY CASTON -1978 'Her life is in his hands'

OHHHHHHHH,
the little mermaid.

This is the part
that kills me.

She is there,
on the boat,
with……

the **one** she loves!
The one

she gives up her voice for.

Her life is in his hands!

57

Mermaids Tale – 1996
'Echoed by the hideous Leach "Turn
to sea foam! Turn to sea foam! You
shall surely turn to sea foam!"'

He couldn't settle down.
Ever!
He wasn't made that way.
He was one of those people,
alive but cursed…
cursed, truly cursed.
Because all that he is and does
is overshadowed by his inability to

SETTLE DOWN.
Would you PLEASE

SETTLE down !!!
IF you cant
STOP THAT

Mermaids Tale 1976
'Because all that he is and does Is over shadowed'

Well John …

he was a terrific……
You would think
terrific at playing the
horrific LEACH!

I thought so. But…
No.
He was an excellent
Reef.
Our underwater love interest.
Reef, a merman who loved Marina, the
mermaid, and was willing to die
for her

Mermaids Tale - 1979
'I thought so but…No'

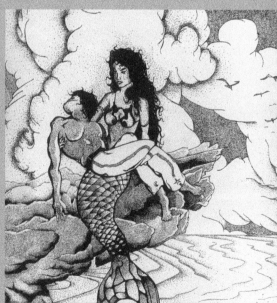

POSTER -MERMAID'S TALE – 1996 - BY
BEN HAZARD
'Her life is in his hands'

So through struggle and
a battle of strength,
will, and endurance.
Reef,
(played by John the first time
the
play was created – 1975)
Reef struggled and fell,
got up one more time, and
shouted;

"SEA WITCH!
GIVE ME WHAT I CAME FOR!"

GIVE ME
MARINA'S LIFE
BACK!!

SUDENT RAW ART

Ahh the drama.

This boy
I wish I could say turned
out well.

And I don't know.

But I do know
things went from bad to
worse, to worse for him
so many years ago.
Certainly
not because he was in a play
and did so well.

I will say this;

He was not safe.

I am not safe.

Our plays are not safe.

The Raw Art room is not safe.

STUDENT RAW ART
I will say this He was not safe I am not safe
Our plays are not safe The Junk Art room is
not safe

A play

that starts out with us looking you in the

eye

and saying;
"What do
you want to
be?"

And,
"What you
say
can
change."
In fact
everything
changes…
…

Mermaid's Tale – 1979

'The experiment Let me beg you to understand this The experiment is not safe Because the
ending of the play really isn't a sure thing '

really
isn't a sure thing.

Till

all the pieces fall into place.

Till

everyone has acted off each
other
for quite a while.

Till

Mermaids Tale – 2017
'everyone here fits in their own way'

you know me and I know you
in ways
only theater,

61

singing together,
dancing together,
weaving our story together,
and hitting and missing
the timing
of all.

Especially the jokes.

Life is a Joke

Laugh at it
Laugh with it
Start laughing

-Joie de vivre-

STUDENT RAW ART
Singing together, Dancing
together, Weaving our story
together, And hitting and missing,
the timing Of all. Especially the
jokes.

ONE WILD THOUGHT

COMES TO PLAY IN MY THOUGHTS

1976 OAS – GOOD THE BAD THE INNOCENT AND THE UGLY

ONE WILD THOUGHT COMES TO PLAY IN MY THOUGHTS

Maureen in the mid 90's

as I consider Maureen's always good plays.

And my always loose and wild scarily dangerous (might do something wrong) (what if someone gets hurt) plays.

A poorly. Dressed Big E

Like for instance 1975

The Good
The Bad
The Ugly and
The Innocent

A play about
bike racing.
Performed
on the stage of Peabody
School.
Where
the brand new created

OAS,
Open Alternative School, had
classes in the temp space
found by The School District.
Gwen Phillips was the
mastermind of this new
alternative school and there
was no stopping her.

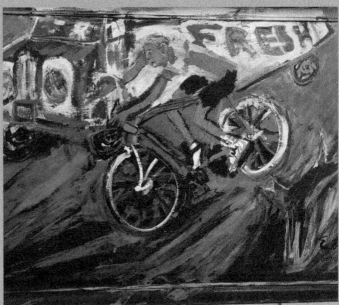

Original Painting by Eric Lehman 1994
'The Good The Bad The Ugly and The Innocent
A play about bike racing'

By **Liz Varni-Rivera** | Tue Feb
03, 2015 | 6:00am

64

Gwen Phillips Courtesy Photo

The children of Santa Barbara have lost a true champion of educational innovation with the passing of Gwen Phillips. She dedicated her life to empowering, enriching, and defending public school children's education. Although Gwen started her teaching career with the Santa Barbara School District in 1955, her passion and vision to establish an alternative public school 40 years ago was the culmination of a long career of establishing a classroom based on the principles of open education. During a sabbatical to study the alternative education movement as theorized by the likes of Herb Kohl, A.S. Neill, and John Holt, Gwen and a group of interested students, parents, teachers, and community members proposed the establishment of the Open Alternative School (OAS). Gwen's endless hours and dedication resulted in OAS opening for enrollment in the fall of 1975.

She gave me full reign to do a play that day in 1975.

Oh yes,

Dana,

from Free School,

who,
transferred
along with
the rest of

the Free School
to OAS,

played

THE BAD.

His younger brother Turk
played

THE INNOCENT.

They were Jarves and Darbo of the Free School

Jarves and Darbo plays.

Dana and Turk
came up with the name Jarves and Darbo
and were in all the episodes of Jarves and Darbo.

STUDENT RAW ART
She gave me full reign to do a play
that day in 1975

MIDSUMMER NIGHTS EVE– 1993–
'the other Free School transfers corralled'

And when

they choose to act
the
rest of the kids
joined us.

And now,
just like then,

Nothing like
live theater

with

LIVE BIKES!

Woopee!

End of the play is coming.
The closure.

This one day show we
designed
and
rehearsed outside during
recess

had a full house.
In
the multipurpose room
with a stage

they sat expectantly.

And then…..

and THIS show was
GONNA BE good

STUDENT RAW ART

I stepped out on the stage.

And using my stage voice,
I announced loudly,
to get all the people's attention,
not for the first or the last time,

"LADIES AND GENTLEMEN WELCOME!!!! And now
without further ado.....
ON WITH THE SHOW!!"

The actors

established
why

the good bike rider
was good,

the bad
bad,

and the innocent and ugly

were worth calling

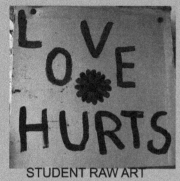

And here
I want to tell you
that one consistent thing
about stories
that would be developed
in
this one day creative venue
is
that almost if not always

the bad would change their ways.
They
would see what they did…
how they were…

'LAST PAGE OF <u>DIFFERENT KINDS OF</u>
<u>PEOPLE</u>'–1973 '
'This play was written from memory from one of the
improvised 'one day plays' performed at the Montessori
School during BigE's first year directing plays there'

So
BAD BOY BIKER,
Dana,
As BAD RIDER
was seeing how he was setting up
INNOCENT RIDER,
Turk

for a mortal ride.

THE RIDE OF
DEATH.

This ride of death
was going to be,

STUDENT RAW ART
'Was seeing how he was setting up INNOCENT RIDER,
Turk For a mortal ride'

perhaps,

not well thought out by BigE.

But I don't think BigE,

never
before or after,
considered riding off the stage
down the middle isle

to be a bad thing

STUDENT RAW ART
'Perhaps not well thought out by BigE'

I can remember standing in the theater
thinking to myself.

I was 21.

And I was pacing out the place, thinking,

how can I make this play great?

Stop for a sec.

Maureen's plays were great because she spent months of after school or during school or even bring kids to her own house time.

LORD OF THE RINGS – 1996 –
Maureen getting ready to play Galadrial
'Maureens' plays were great because she spent months'

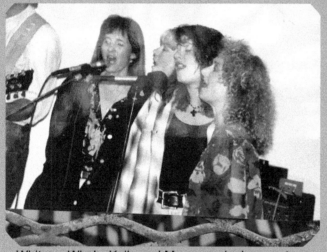

Whitney, Windy, Kelly and Maureen singing on stage
1994
'She would work it. (the play) Work it till all the kinks were out.'

And again she would work it.
(the play) Work it till all the kinks were out

Me?
I was looking at the special things to do so everyone would be wowed.
And, they would remember

the cool kids

doing

STUDENT RAW ART
'looking at the special things to do so everyone would be wowed'

71

DANA ROAD!

(He had the part because he was the only one I trusted to pull this stunt off.)

HIS BIKE LEAPED
OFF THE STAGE

landing perfectly center of the middle isle.
His

BAD CHARACTER

sacrificing His life For

THE INNOCENT.

Riding out the
multipurpose room door.

And sadness to be felt
by the loss of a bad boy
turned good

and
giving up his life.

Well I didn't exactly go all emotional.

The other three bike riders decided

they too should
ride off stage.

To hell with the story.

But,

one person

did not like it at all.

Dr Hanlon, the principal of Peabody,
(who probably was not at all happy to
have OAS there
in the first place.)

she came

tromping

down that isle.

The bikes had just exited through

like a locomotive train.

"This kind of activity is NOT! I repeat NOT! Allowed!!!!!!!"

STUDENT RAW ART
But One person did not like it at all Dr Hanlon The
principal of Peabody

STUDENT RAW ART
" This kind of activity is NOT, I repeat NOT allowed!!!!!

KID'S ART
'BigE was just a wild card about to
go bust'

Maureen was good.
Her plays were art pieces.
Sets, costumes, acting,
singing and so on.
BigE
was just a wild card
about to go bust
But......

73

I CAN ONLY
SAY IF ONE
TRYS HARD
ENOUGH
1978 -
MONTESSORI -
AFTERMATH

STUDENT RAW ART

I CAN ONLY SAY;
IF ONE TRYS HARD ENOUGH
you will achieve results.

The proof is in the pudding.

I laid down a plan or two in my day.
What plan could be more important
than
the plan of a lifetime?

I rarely struggled with anything.
I was oblivious
to
the impossible threats to a
substantial life.

STUDENT RAW ART
'I was oblivious to the impossible
threats to a substantial life'

That being;

I did not write the play Aftermath.

Hogwash! It flowed from your fingers.

Oh sure. But where did it come from?

APPLE 2e –
'I wrote a play on an apple 2e'

This is why
one day
I wrote a play – on an
apple 2e.

Out comes,
what some consider,
the greatest play ever
written by man.

'the death of mankind World
extinction Because of man's
inhumanity to man'

STUDENT
RAW ART

75

through forgiveness
through love.

But,
it's not so simple.

Can kids possibly make a difference?

Oh yes they can!
In the idyllic world,
inside the mind of God,
it is possible.

And, inside the positive,,,,

receptive….

okay
I've got to be honest here.

Not necessarily everyone thought this
play was superior to all plays
known .

Junk Art Room

STUDENT RAW ART
'Oh yes they can In the idyllic world inside the
mind of God… it is possible'

I wasn't counting.

STUDENT RAW ART
'deeply distressed with the poor spelling I
was presenting'

In fact I remember
bringing in another play I
wrote,
for a Montessori teacher,
lets call her Diane,

She was deeply
distressed with the poor
spelling I was presenting
the kids with.
 when Sue,
 who was the teacher of the older kids,
 the 11 and 12 year olds,

Sue had the audacity to suggest
to Diane,
the teacher who was surely upset with spelling,

"Well all I can say is!!!!!"
The older kid's teacher, Sue, said; "Don't you think Eric exhibits genius in his play Aftermath?"

If you could see the look on Diane's
face
at the thought
that this badly spelled,
untrained,
simple minded,
hippy of a kid,
who

doing plays with the kids,

never gotten degree for all that is
good in the world.

STUDENT RAW ART
'badly spelled untrained simple minded
hippy of a kid'

KID'S ART
'he is not adhering to any sort of controlling
body of logic'

Where do you get off saying he has genius?
Genius comes from a perfect pen
to perfect paper,
from perfect people.
It does not,
I repeat
NOT,
come from some
loose lipped excuse.
He's not pretty
he's messy.
He comes off as sweet?

and understanding.

Simple and straight forward

he is.

He's not sweet.
He's a hard nut
stuck in his sense of
free form running.
He can't listen.

And, he is not adhering to
any sort of controlling body
of

A wild child
with an untamable nature.
Where he feels these little
shows he puts on with kids,

in particular Aftermath,

well
he thinks

Don't think he ever ever thinks about the future!
Or,
and this is a big one,

that's all that is

I don't think he
Cares!

happening!

Now that's where she was wrong
I did care…

exert from script

NATE
Buddy is not a jerk.
DAVINA
How come he's been gone for two days without saying a word to his friends?
SONJA
He's not the only one with problems.
DAVINA
I wonder if Tony is all right?
NATE
After the war, it was like we all had the same pains, almost a universal group loss. But then on top of that, after you think it's all over, to lose your brother. Buddy had had it. If not for the rest of us he would have gone berserk. I mean give him a break. Buddy had had it. If not for the rest of us he would have gone berserk. I mean give him a break

The play,
about
the boy survivors
and
the girl survivors,

End of exert

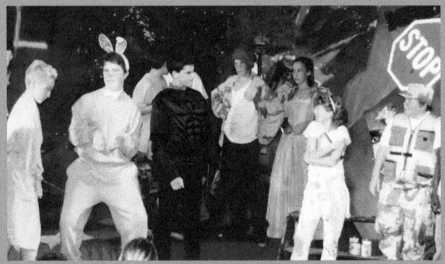

AFTERMATH– 1998 'will he ever be able to be happy
if he's hating so much?

my play,
my masterpiece.
Ah the play
Aftermath
had it all.

One boy,
Buddy,
in the end,
Trying to
struggle with his
conscience;

"I hate these kids who
inadvertently killed my
brother.
After all I went through.
And those freaks need to
pay for what they've done!
They killed my brother!"

KID'S ART
'My play My masterpiece Ah the play Aftermath Had it all'

Just as Buddy,
who's brother was killed by the
Dragons,

the Dragons,
a rag tag group of ridiculously
dressed hooligans,

exert from script
BUDDY
(yelling)
The enemy killed my brother. They have to pay
for what they did. Don't you see what they're
doing? They did it once they'll do it again.
They're crazy! They gotta be stopped.
End of exert

who,
inadvertently
destroyed a building,
that
was the finale vestige of what
remained.

BUGS

This hearing of the death of a Falcon will now come to order.

BATS

As I see it sir, after the holocaust the falcons make their home on Elm Street, in the only building left standing.

ALL

The Neighborhood Center.

SHIEK

Built before the bomb by a group of parents for their children. An effort of love.

TEDDY B.

Built before the bomb by a group of parents for their children.

(very sweetly)

An effort of love.

SPIKE

The Falcons resided there for a number of days.

LUKE

Until... the Dragons returned.

End of exert

That
was an empty building
their parent's hopes and dreams
would never see come to life
because
all the parents were dead.

And,
the Dragons destroyed the building
not knowing
they had also
destroyed the life of Buddy's young brother.

STUDENT RAW ART

'became all about vengeance Supreme vengeance
If not that then certainly he could never forgive'

And therefore,
the life of Buddy,
who,
became all about vengeance,
supreme vengeance,

If not that
then certainly he could never forgive.

it wasn't
forgiving
that needed to take place.

It was # help this
boy,

who was trying to kill himself,
that had brought out the soul of
love
from Buddy.

exert from script

TONY
I didn't know it would be so painful. My brother didn't have pain.
BUDDY
What are you talking about?
TONY
(spasms and screams)
THE WATER WAS SUPPOSED TO KILL ME! I didn't know it would be so painful.
BUDDY
Water? You're trying to die?
TONY
Yes! I called it bad water. But it's good. It'll take me away from here. I'll see my
brother again.
BUDDY
Don't.... no...don't do this.
TONY
My brother died. He left me alone. Everyone left me. I just want to die.
Buddy pushes Tony away and starts to back away from him.
BUDDY
You fool! To give up like that is wrong. Go ahead, die! You deserve to die! People like
you don't deserve...
Tony goes into spasm again.
Buddy rushes back to him.
BUDDY
Don't die! Don't die! Don't leave me!

TONY

Mike? Mike is that you?
BUDDY
No! Yes! I'm Mike! I'm whoever you want me to be! I'm your brother. Just don't die!
TONY
(really looking at Buddy)
You're my brother?
BUDDY
Yes for Christ's sake, I'm your brother. You're not alone. I'm here. Don't let yourself
die! My brother died, I know how it feels,
How lonely it can be...How unfair it is.
But I know now that's past...
There's nothing I can do about it.
Forget the dead and take care of the living.
I want to care for you. I can't do that if you die. Don't die!
TONY
(very quietly to himself)

Good bye Mickey.
(standing)
Goodbye Mikey.
 end of exert

LEORA ★

STUDENT RAW ART

'Yes for Christ's sake, I'm your brother. You're not alone. I'm
here. Don't let yourself die!'

end of exert

His transformation was
indeed
on the verge
of working the audience
into tears.

When,
oh no Holy crap,
an actor,
then two,
then three,

Started

laughing.

At what I don't know.
But all sorts of
chuckles
and guffaws
took place.

There, on

my opening night,

ruining this genius
for good.

No more was

82

the thinking
that all would be perfect,
able to truly take hold of
Eric's psyche.
No,
he knew without a doubt,
that,

whatever can be raised by
man to heaven,
can indeed,
oh yes,
whenever I might think my

treasure is all the top,
that top is when I raised my
gift,
mine mine mine, up to
heaven,

down it can fall to earth
any time any time.

STUDENT RAW ART

'there on my opening night Ruining this genius for good No more was the thinking that all would be perfect'

Down it can fall to earth
Any time Any time.

ALL
RIGHT
KIDS

(1985 – SAMMY BOY BITES THE DUST)

KIDS ART

ALL RIGHT KIDS!
[4 – 5. Year olds at a Montessori School]
1985
"All right kids!"

This was raw stylized theater.
"Kids you are animals.
Be animals."

'"All right kids" this was raw stylized theater
"Kids you are animals Be animals

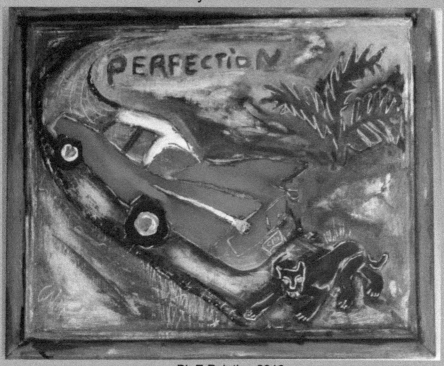

BigE Painting 2016
Often a wild cat And I would growl

STUDENT RAW ART
'can we blame little Sammy
boy'

So can we blame little Sammy
boy,
4 years old,
for biting me on the butt?

Of course not.

Now wait a second.
To tell this story
we have to go back

to 1973 through 1976.

There were these
phenomenal

phe·nom·e·nal

1.
very remarkable; extraordinary.

wrestling matches

between
BigE (then in his early 20's)
and
the 5th and 6th grade boys.

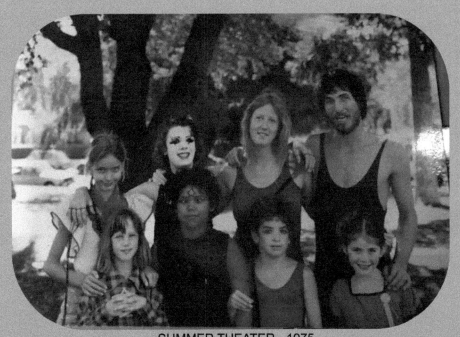

SUMMER THEATER - 1975
'Now wait a second To tell this story we have to go back'

KID'S ART

'there were these phenomenal wrestling matches between BigE (then in his early 20's) and the 5th and 6th grade boys.'

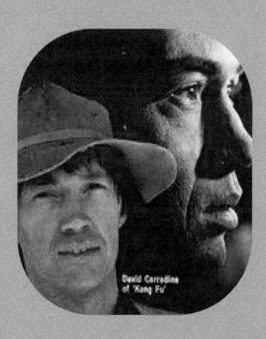

Kung Fu with David Carradine. We, Brother David and I, watched every episode.

STUDENT RAW ART
'The Montessori boys Would circle
around and get thrown around onto their
comrades collapsing quickly'

The Montessori boys
would circle around and
get thrown around
onto
their comrades,
collapsing quickly,

giving me time

to

then

deal with other attacking children.

And as time passes,
Instinctually,
now this is important,

I had to be fast
so as not to get hurt.

Instantaneously
fending off
and
pushing kids away,
and

STUDENT RAW ART
Instantaneously fending off and pushing kids
away and down

down, yes,

will attack.

That's what I said

this poor old 65 year

old man

attacked

by young 14 year olds.

catching
falling items,
or...,
and this is
important,

STUDENT RAW ART
instincts became good

and this is important,

STUDENT RAW
ART

instincts became good

So of course

I catch their fist quickly
in mid swing
and
toss them fist and all to the
floor
with a swift

Wapp
Wapp.

Back to the 4 year old biting the butt.

1985
BigE was young,
fast,

learned to be instinctual
out of self-preservation.

A bite.
Pain!

Wapp!

Wapp!

Slap like you would a fly.

But this slap

hit the

4 year old

Sammy boy,

growling beast.

STUDENT RAW ART

I had told these cute little kids to
act like animals.
Sammy boy was ferocious!
(By the way the bite he laid on
was nothing to laugh about)

Wapp!
Wapp!

He went flying across the stage

where
this little kid animal workshop
was being held.
Sammy boy hits the back wall!!

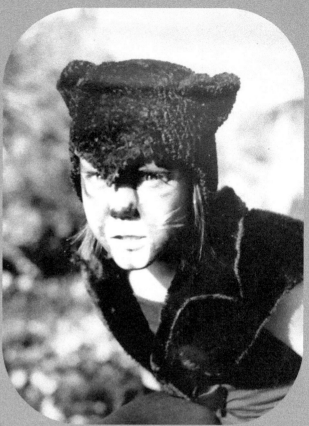

JUNGLE BOOK 1977
'Sammy boy was ferocious!'

This was pure instinct, didn't think a thought,

the wall!

until……

slowly to the floor

after hitting the wall at the back of the stage.

Silence.

Sammy Boy slides

Everyone
everyone froze,
stared.

All
eyes
looking
at
Sammy Boy.

eyes

He
opens his eyes

All

looking

STUDENT RAW ART

at Sammy Boy

Junk Art Class

Starts to

growl

and
jumps up
to

attack me

yet again.

Oh yes the jokes on me.

STUDENT RAW ART
'Oh yes the jokes on me.'

OKAY LET'S JUST SAY YOU COULD OF SAID THINGS WERE GETTING UGLY... VERY UGLY.

STUDENT RAW ART

OKAY
LETS JUST SAY
YOU COULD OF SAID
THINGS WERE GETTING UGLY…
VERY UGLY.

My favorite part of this story is the
end.
It spoke very clearly to me

about;

You stick with me boss
and everything will be okay,
no better than okay,
magical…
Just trust
in
that which speaks without
words,
moves and touches our
hearts
when we really need it.

But,
getting back to the
beginning
where all things in this adult
play,

that is,

the swan song of my
creative life.

The opus.

My moment
when things where so
wonderfully good
and life was so sweet

that the thought
that things might not
work out

was out of the question.

What question?
What play?

Girl on a Rock
of course.

The only original adult play I have
ever recorded and kept.
Because it is so good
I actually have the pad with the
original writing.
It's worth Millions $$!
Oh yes!

All kidding aside I love this play

about two women.
One, Abby, strung out
on heroin.

Dearest Debbie Boo-

The time has come. I want you now
to come and be at my disposal.
Don't wait till later. Come now. I
repeat I need you now. Please don't
stall.

Yours always with much love
Abigail

But you don't know that
till
the middle of the play.

The other woman, Deb, is
… well….

a realist.

STUDENT RAW ART 'My moment when
things where so wonderfully good and
life was so sweet that the thought that

A straight-shooting
individual
who gets
a letter
from a friend, Abby.

behaviors exhibited by the
woman. (her friend Abigale)
What was Deb going to do?

A friend
who truly stood with her
at a very
difficult time.

And,
they made promises
to each other,
promises of love and
loyalty.

So, Deb, the straight
forward gal,
leaves her ordered life,
very ordered life,

and,

enters in a maelstrom
of

hideous and obsessive,

strikingly repulsive,

This was
insanity.

Then
to add to her
deep
confusion
whether to go
or stay,

STUDENT RAW ART
' hideous and obsessive strikingly repulsive behaviors'

exert from script

Girl On A Rock
By Eric Lehman
Written in 1986
[This is a FLASH BACK that takes
place while Deb is musing]

DEBBIE: Abby you're never serious.

ABIGAIL: I gotta go, bye.

DEBBIE: Listen, what about bonding or whatever? I thought we were gonna make our friendship tied or something.

ABIGAIL: You're not the kind of person who can do that.

DEBBIE: Hey wait a minute!

ABIGAIL: I'm sorry this is serious, and I don't think you can handle that.

DEBBIE: What?

ABIGAIL: Our friendship. I don't think you can handle taking our friendship seriously.
So bye - bye.

DEBBIE: Abby.... *(pause)*

ABIGAIL: WHAT?

DEBBIE: *(looks Abby in the eyes seriously)* I want to take our friendship seriously.

ABIGAIL: Promise me you will always be there for me.

DEBBIE: I will always be there for you. But you must always be there for me.

ABIGAIL: *(to Deb)* Shhh. That if the time ever comes when I need you, you must come no matter what's going on. You drop everything and come to me, because nothing is as important as our friendship.

DEBBIE: Abby, you know...

ABIGAIL: Promise me.

DEBBIE: I promise.

ABIGAIL: What?

DEBBIE: What?

ABIGAIL: What do you promise?

DEBBIE: I promise to always be there for you, to come if you call, no matter what's happening.

ABIGAIL: You have a very hard shell around you but inside you're genuine and true.

<center>End of exert</center>

The straw that broke the camel's back was

Abigale's problems

(or so it seemed)

stemmed from her

addiction,

A very progressed condition of heroin addiction.

The straw that broke the camel's back

Not a happy scene.

98

exert from script
Girl On A Rock
By Eric Lehman
Written in 1986

SCENE 5 ABIGAIL'S KITCHEN
[Debbie is making a cup of coffee.]

DEBBIE *(burns herself)* Oh shit.

ABIGAIL: *(eyes have circles, looks ghostly white)* Good morning.

DEBBIE *(still facing coffee not looking at Abby)* I was wondering when you would come down. You've been in that room of yours for a long time. What do you do in that room of yours anyway?

ABIGAIL: Oh god Debbie.

DEBBIE *(turns at this time, sees Abby for first time this scene)* Shit! Abby you look awful!

ABIGAIL: I feel bad Deb.

DEBBIE: Why didn't you tell me you were sick?

ABIGAIL: I'm not sick.

DEBBIE: Like hell you not.

ABIGAIL: I'm going through withdrawals.

DEBBIE: I don't understand......
(looks to Abby for answer)
[Abby's silent.]
DEBBIE: From What?

ABIGAIL: From shit Deb. That's why I called you here because I'm hooked on shit.

DEBBIE: You? How? Oh fuck! Abby how? How? Oh Abby how? *(walks)* That's bad. I gotta go Abby. I gotta go. Oh Abby! How could you?

ABIGAIL: It was easy. Really no problem. Just got used to it. I like it. Makes me feel good. Don't have to think. Oh god I'm dying! *(breaks down and falls to floor weeping and shaking)*

DEBBIE: *(backing away)* This doesn't fit for me. I don't want to see you like this. It doesn't work for me. I don't want to see you like this. You shouldn't of called me. Don't ever call me! No don't ever call me! *(runs away)*

[Abby is on the Ground shaking and crying.]
END OF SCENE 5
End of exert

At this time

Deb makes

what she was sure
was

the

decision to

get away

from this toxicity,

STUDENT RAW ART
"I don't want to see you like this."

INTERMISSION

WHEN WAS THE LAST TIME I SAW YOU?

I'll be Seeing you in every lovely Summers day.
CHRIS

WHEN WAS THE LAST TIME I SAW YOU?

Was it at a bar drinking martinis?
Or was it being bad down by the harbor?

When was the last time?
Can I count the years on one hand?
On two hands, three, four….?

MID SUMMER NIGHT DREAM 1999 'time is actually irrelevant'

Or has it been mostly forgotten
and the time is actually irrelevant?

Pray speak up mind of minds.
Unleash all your inner self
so others can see you.

Starting with why.

IT WAS LOVE
most DEFINITELY LOVE.
CHASING LOVE.
THE LOVE OF ART.

Replacing
conservative standard
with the wild yet compelling.

Lord of the Rings
years before.

Lord of the Rings 1991– set in
progress
'Wild Yet Compelling'

Legend - 2000
'Teenage Mutant Theater'

The review in the paper -
"TEENAGE MUTANT THEATER"
A title I choose as our way, the only way for us.

AIM AT THE GOAL…,
visualize the beauty,
the emerging Phoenix.

See the play
as a reality that unfolds
one step at a time.
Ahhh the color of costume…
ahhh the dynamic movement,
darkness that the sets seem to exude.

The makeup begins
its soft emotionality on every face
helping the features sharpen
into a fantasy of belief.

Beauty and the Beast 2002 – Dream
Sequence
"emotionality on every face"

Legend - 1994
"into a fantasy of belief"

All this,
afterwards, meaning nothing
except those damn actors.

Those damn actors,
who are they becoming?

Fiddler On The Roof 2012 – Ladies singing -
'Those damn actors who are they becoming?'

ACT II

1988 News in brief

- Robert C. McFarlane, former National Security Adviser, pleads guilty in Iran-Contra case (March 11).

 - ,US Navy ship shoots down Iranian airliner in Persian Gulf mistaking it for jet fighter; 290 killed (July 3).

 - Republicans sweep 40 states in election and Bush beats Dukakis (Nov. 8).

 -

- France and China permit use of "morning-after" birth-control drug RU486 (Mifepristone)

- NASA scientist James Hansen warns congress of the dangers of the global warming and the greenhouse effect

- Ninety-eight percent of U.S. households have at least one television set.

- CDs outsell vinyl records for the first time.

Popular Culture 1988

Popular Films

- Rain Man
- Who Framed Roger Rabbit
- Big
- Twins
- Crocodile Dundee II
- Die Hard
- The Naked Gun: From the Files of Police Squad!
- Beetlejuice
- Dangerous Liaisons
- A Fish Called Wanda
- Friday the 13th Part VII: The New Blood

Popular Musicians

- Enya
- Robert Palmer
- Erasure
- Kylie Minogue
- U2
- The Beach Boys
- Bros
- Michael Jackson with "Dirty Diana
- Gloria Estefan
- Chicago with "Look Away"
- George Michael with "Father Figure"
- Guns N' Roses
- George Harrison

- Songs

Don't Worry Be Happy
Bobby McFerrin · 1988

A Groovy Kind Of Love
Phil Collins · 1988

The Flame
Cheap Trick · 1988

Bad Medicine
Bon Jovi · 1988

Hands To Heaven
Breathe · 1988

When the Going Gets Tough, the Tough Get Going
Billy Ocean · 1988

Simply Irresistible
Robert Palmer · 1988

Fast Car
Tracy Chapman · 1988

I WANT TO BE
THE FOX... NOT JUST
ANY FOX BUT THE FOX!!

WELL OKAY THE BE
THE FRIGGIN FOX.
THEN WHAT? Then
the PLAY Telling a
Story... What is
the STORY ABOUT?
YOU Tell ME?
WHAT'S That
YOU WANT a
STORY TO BE ABOUT

THE MOVIE YOU SAW
LAST Night. AND
WHAT was that?
THAT MOVIE WAS
HOW THE WEST
WAS WON
But that's a
3 ½ hour movie.

LETS PLAY again. Little
PEOPLE goofing off?

NO. LittlEL PEOPLy young Folks
SUPPER INNOCENT in oh so
mANy WAys youths Born
BUT JUST 6 years earlier
OR PERHAPS 5 YEARS ago
they were born. WHAT
do you WANT TO BE?
AHH THE DEPTH OF THINKING
Called upon, AND I am serious
I WANT TO BE A kitten.
A Baby Kittin →
OH I WANTO BE

A brown cow fat
in the middle, yet
short
on one side and
extremely wild
because the cow
has

the lethal
force
weaponry
that seeks
out evil on
other
planets.

in the middle get short
on one side. And Extremely
wild cause the cow has
SERIOUS child good issues
That have been more Pominent
IN Its older age Not
To Be forgotten is
the LEATHAL FORCE
WEPONRY THAN SEEKS
OUT EVIL ON OTHER
PLANETS
NO GUNS SORRY

The world of pretend
never
ends in a young, little
persons,
mind. Why would it?

THE world of pretend never
ends IN a young Little persons
mind. why would it.
OH SORRY I'm confused
NOT EVERY ONE is The same
There for not Every
Tom dick and Harry
can or will do the
same thing so generilizing
Simply won't do.
I WONDER SOMETIMES
IF... AS I WATCH
my LiHlE ACTORS
IF Im allowed iNTo
their world simply
BECAUSE OF CHANCE

OR am I
divinly BLESSED
OR PEHAPS I geT
TO HAVE THE
GREATEST
TREASURE
KNOWN TO
MAN !!!
OR could it
BE I will BE

Therefor not every
Tom, Dick and
Harry
can or will do the
same thing. So,
generalizing

ASKED To give Back
SOMETHING FRom myself
That might
But what could I give
Back that would BE
CLOSE TO WORTH WHAT
I HAVE WITNESSED
IN THE TREASUREFULL
LOVELY Histerical
PERFORMACES OF movie
ALgator Magic dinasours
dancing with invisiable
Fairys along 'side
The ICE QUEEN.

ALL THOSE Kids ALL THAT
FUN NEVER A dull moment
did I FORGET TO TELL you
ABout ACT 1 Two and 3
or is it possible IN
the super SPEED Dramas
To TRULY Express the
divine Expression of
LIFE and DEATH of
dance and POWER
OF The hearalding
cocophony OF
SWEET AND Thourgh
EXpression expressed
IN MOMENTS AND Yet
a FOREVER STORY.

MAY I NEVER FORGET
THE ExQuisit memory,
may I Always Remember
How
PRECIOUS THESE
@Children ARE
WERE did They
come FRom where
are they going
OH PLEASE God
How HAPPY I
get TO BE

Oh please God
 How happy I get to be.

HOW ANXIOUS I AM TO
ESTABLISH,
NOT THE FRIENDSHIPS OF
CHILDHOOD,
BUT
THE BIZARRE AND
STRANGE LANGUAGE THAT
TRANSPIRES WHEN OLD
AND NEW BEGIN TO CHAT.
*(2009 – THE COWARDLY
LION]*

How does that conversation go?

Ah how about this one?

The angel,

he who showed up,
because of the way we are.

He was an exceptional actor.

Ahhh yes
I remember now.

We were all so surprised at his

yelling loud voice....

Little, and I mean he was a little guy, little
Dylan.

'we were all so surprised at his yelling
loud voice..... little and I mean he was a
little guy little Dylan'

He would shout out the smallest of lines.
He was one of those actors that.....who.....
makes a show so funny to watch.

And, it was his first time as an actor.

It was the first time we performed the new version of

The Cosmic Cools.

Kid's Art
'Dylan was the master of loud talk'

Exert from script

The Strange Magician.
Lieutenant Steve Hammer and
Agent Kelly interviewing the
family;]

STEVE: Do you watch a lot of TV
Big Guy?

BIG GUY: Well I watch Saturday
Morning cartoons Lt. Hammer.

STEVE: Just call me Steve.

KELLY: What about you Mr. and Mrs. Smith. Do you watch much Television?

MOM: Just the normal amount. You know after school and work a little T.V. is the perfect thing to relax in front of.

DAD: And of course Monday night Football.

BIG GUY: All my friends at school watch T.V. Steve. How else would we know what's cool?

STEVE: Ever heard of the Cosmic Cools son?

BIG GUY: Sure who hasn't? They're the greatest.

STEVE: They're cool and they're real. Not just actors in a studio.

MOM: Everyone watches Television Lieutenant. After all how would we know what's going on in the world if we didn't watch the Tele.

DAD: What's all this interest in a little harmless entertainment.

KELLY: Perhaps not so harmless Mr. Smith. With *Strange Magician* around it seems watching T.V. could be hazardous to your health.

Wizard of Oz Poster – 2018
'after the allotted time has passed We noticed this strange thing that happens'

Robotitus!
Yes the truly ugly and devastating disease caused by an awful and strange recurring nightmarish pariah.
A malady caused by none other then….. a script! The written word is the cause of it all.

Junk Art Wall
"truly ugly and devastating disease caused by an awful and strange recurring Nightmarish pariah"

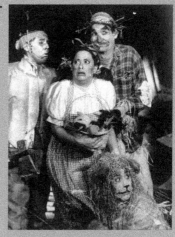

Adult Wizard of OZ – 1998
'what kind of magical gist of intelligence you were born into'

Revisiting Wizard of Oz for the umpteenth time.

ADULT- WIZARD OF OZ- 1998
"There's a good chance you will stink in oh so many ways when you start delivering your memorized lines"

Kid's Art
'Rehearsing for the first time With these 2nd and 3rd graders And one kid was dynamite without a script'

James was dynamite....

without a script.

The
Cowardly Lion

Oh yes he **was** dynamite without a

script.

But I've got to tell you about the two Toto's first.
We had two Totos during the show. Because we had two who really, really, really,
wanted to be those cute little dogs. And oh God they were cute. So story goes on.

And the Totos get into the scene with the talking trees..... and the

apples.

THE CARDBOARD KING
'Because we had two who really ,really, really, wanted to be those cute little
dogs.'

INSERT FROM SCRIPT -Dorothy and Scarecrow enter skipping.

DOROTHY Oh -- apples -- Oh look! Oh. Oh ---she picks an apple off

THE TREE TAKES THE APPLE BACK AND SLAPS DOROTHY'S HAND --

DOROTHY Ouch!

TREE What do you think you're doing?

DOROTHY We've been walking a long ways and I was hungry and --
Did you say.

FIRST TREE She....WAS HUNGRY! WELL, HOW WOULD YOU LIKE TO
have someone Come along and pick something off of you?

DOROTHY Oh, dear -- I keep forgetting I'm not in Kansas.

SCARECROW Come along, Dorothy -- you don't want any of those
apples.

FIRST TREE What do you mean - she doesn't want any of those
apples? Are you hinting my apples aren't what they ought to be?

SCARECROW Oh, no! It's just that she doesn't like little
green...worms!

TREE Oh...you...I'LL GIVE YOU little green apples....

SCARECROW I'll show you how to get apples.

First Tree laughs **as it throws apples.**

TOTOS PICK UP APPLES ALSO.

Wizard if OZ – 1993 - Scarecrow and
Dorothy
'I had a sharp eye for the little things that are going
awry'

Well all is fine.
Tree's throw apples.
Toto's picks them up.
What?
Totos?
That,
is when things
started
going awry.

a·wry

adjective

1. away from the appropriate, planned, or
expected course; amiss.
"I got the impression that something was
awry"

And off they go!

As the story keeps moving on,
with the actors doing their parts,
I noticed something.
(By this time in my life I had a sharp eye for the little things
that are going awry)

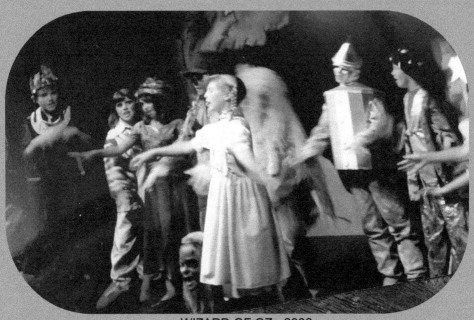

WIZARD OF OZ - 2006
'As the story keeps moving on with the actors doing their parts I noticed something'

KID'S ART -WIZARD OF OZ
'I had a sharp eye for little things that are going awry.'

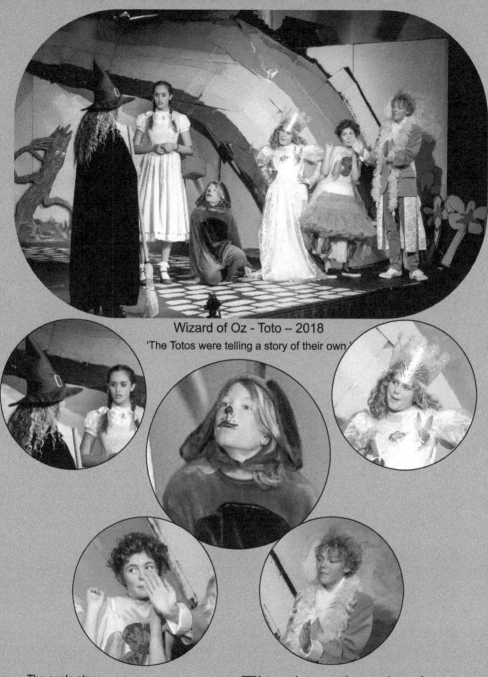

Wizard of Oz - Toto – 2018
'The Totos were telling a story of their own.'

The apple story.

TOTO 1:
"RRRRuff rrrruff I have the apple"
TOTO 2:
Ruff rrrrrruff I have the apple."

The 'apple play' continues on through the evening

to it's climax.

Exert from script

OZ'S VOICE: NOT SO FAST! I'LL HAVE TO GIVE THE MATTER A little thought. Go away and come back tomorrow!
DOROTHY: Tomorrow? Oh, but I want to go home now.
TIN MAN: You've had plenty of time already!
LION: Yeah!
OZ'S VOICE: Do not arouse the wrath....
Toto runs to a curtain that hangs near the throne steps

But no totos are anywere to be seen!

OZ'S VOICE
...of the Great and Powerful Oz! I said come back tomorrow!

NO TOTOS!!!!!

Until....

across the back of the stage

One Toto running after
the other Toto

As dogs
mind you
Playing out their apple story
Something like;

TOTO 1
Ruff ruff its mine"
TOTO 2
(grabs apple) Ruff ruff I've got it now
TOTO 1
Ruff ruff I'm chasing you "
They were in character.

Back to this,

Cowardly Lion,

with this little fantastic kid,
James,

knew every line

in every scene.

This guy, this little 8 year old James,
was hysterically funny.
He had the Cowardly Lion down,
word perfect, and all the expressions
that went with it.
Until.......we gave James

a script.

Dead in the water. From that time on, James
couldn't remember his lines.

one more casualty

Death by script

Wizard of Oz – 2017
"dead in the water from that time on he couldn't
remember his lines"

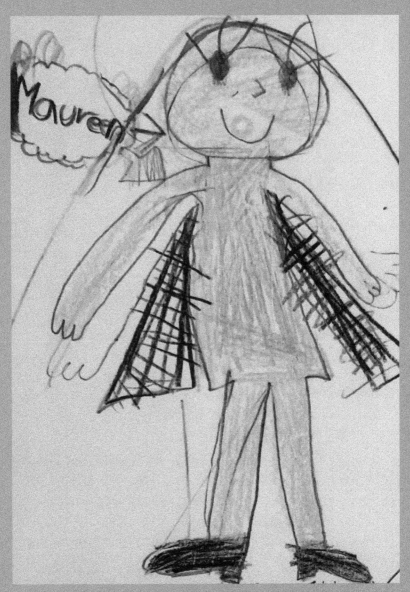

MAUREEN

A letter from Maureen's sister

To dear Maureen,

In looking back over our relationship through the years, I go back to when we were very young – probably 10 and 5 yrs old. You were so darn creative even then! I remember you had me (almost) convinced that tiny fairies lived in our flower garden (even then logic pushed its way to the top of my brain, so I was still a bit skeptical): you loved playing "dress-up" with me until one day you told me you were too grown up.

Maureen, John (brother), Margie (sister)1955
"You were so darn creative even then."

That magic Maureen brain powerfully influenced me and still does: when I make art or play piano or hear some great music or find something cute to wear, I think, "I wonder what Maureen would think?" and when I'm walking Jimmy and see something beautiful I'll wish you were with me because you'd appreciate it. I wish we both had millions so we could see each-other more often.
Love you,
Margie

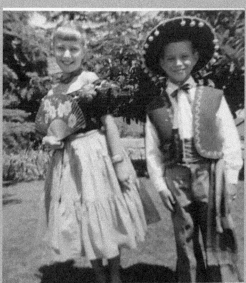

Marueen and John – Fiesta
"You loved playing dressup"

Thank you very much for playing the music for our play, with our voo.we would sound disasturous.

KID'S ART / MAUREEN

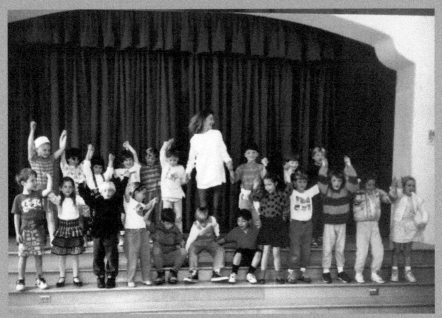

MAUREEN DIRECTING PLAYS AT COLD SPRINGS SCHOOL 1988 THROUGH 1992

LORD OF THE RINGS 1996
MAUREEN IN 1957
Could have been Eric and Maureen
Eric 2 Maureen 11

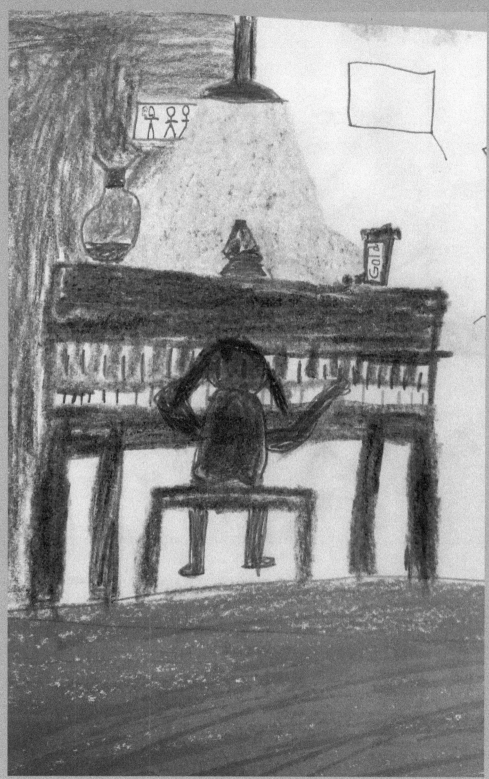

131

IF SO,
THEN WHY?
{1988-ADULT
DRACULA }

August 3, 4 & 5.

POSTER / Dracula *A Teenage Fantasy* / 1986

IF SO, THEN WHY?
Why else
is really the question.
For instance, if you were
to sail a million miles
into the sunset would
you be bored, or excited,
hungry, tiered, deeply moved.....

That's all going to happen
on a daily basis in the
life lived going into the
sunset. Which brings me
to the inevitable day,
that day of all days,
the hungry moment,
when I looked at my
own sunset and

STUDENT RAW ART
'I wasn't just going to live I was
going to inspect the **inside of the souls**'

I was going to inspect
the inside of the souls
I work with. And, be
part of the solution.
The answer to life's
problems;
 the joy,

KIDS ART
Humor That always dances and
prances around manifesting itself

RENFIELD IN DRACULA / 2000
'all things said and done If I didn't it wouldn't be there
If I did then well the show would go on and the
memory would be there forever'

and mostly the humor that always dances and prances around manifesting itself in oh so many ways.

One way in particular comes to mind.

That day, the one when all things said and done.... if I didn't......... it wouldn't be there....... if I did, then...... well, the show would go on, and the memory would be there forever...

Yes yes yes to the adventure of an adult play **Dracula.**

As always the fact
that Maureen and
I both loved the
dark story, and
we were driven!

For that way, that way,
the story, the story.

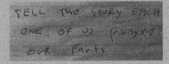
TELL THE STORY EACH
ONE OF US playing
our Parts

Me

COUNT **DRACULA**

Maureen

PROF. **VAN**

HELSING

Marco

DR. SEWARD

We were destined as
part of this story too……
And now, yes once again

DEATH PLAYS ITS
PART

Her character,

Van Helsing,

was to…

kill my charachte
DracuLA By Running
a Stake Throug my
HEART

But this, only after
we faced off. And

Van Helsing, herself,

struggling with her
power to overcome

Dracula's will…….

She was to overcome his will
with her own willpower.

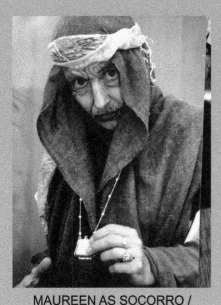

MAUREEN AS SOCORRO /
BEAST / 1993
'She was to over Come his will with Her
own will power'

BUT NO
THIS WAS NOT
TO HAPPEN

Because…
But first let me say;

NOTHING IS ALLOWED
TO disRupt A STORY
LINE… UNDER NO
CIRCUMSTANCES cHANGE
THE FINAL OUT COME

VAN HELSING

KILLS DRACULA.

This is not
what happened.
No….. In the
show there is
A CHARACTER
named Doctor
Seward. He's
Played by Marco.
He looked around
The set falling

played by Momo,
she started shouting;
"My leg my leg!"
Hoping to give some reality to the part,

STUDENT RAW ART
'Helsing kills Dracula , this is not what happened…NO'

He……

DRACULA - 1990

killed

Dracula.

By accident?

NO…… because….

First let me say I was excited
to be innovative with the sets.

They would fall down as
Dracula began to die.

…well

STUDENT RAW ART
'HE killed Dracula by accident NO because…..'

Exert from script

Entering Carfax Abby to Kill Dracula

All start gasping putting hankerchiefs to their mouths because of the smell.]

SEWARD ((MARCO)): Oh God what a stench. You can't seriously expect me to believe that Count Dracula is some hideous monster.

HELSING ((MAUREEN)): I don't expect you to believe anything but what is. If we fail here, it is not merely a matter of life and death..... it is that we shall be come such as he. That we and your Mina..

SEWARD ((MARCO)): It's not possible

HELSING((MAUREEN)): Will become foul things of the night...There is work.... wild work to done. And now... with all the powers of the devils against us....

[Dracula ((BIGE)) enters.]

DRACULA ((BIGE)): Who dares to disturb my sanctuary on my wedding night.

HELSING ((MAUREEN)): Your time is up.

JOHN HARKER: Bully for you Professor.

DRACULA ((MAUREEN)): (laughing) Do you think with your cheap tricks you can destroy me? Mina Come to me.

[Mina steps out in wedding dress.]

SEWARD ((MARCO)): Mina get out of that silly dress and come here right now... I'm still your father.

DRACULA ((BIGE)): I am KING of my kind. In a century when you are dust, I shall wake and call Mina, my bride.

HELSING ((MAUREEN)): In the name of the Lord and the power of his might.
[John pushes Dracula against the Cross and he starts to burn. Helsing rushes him and drives a stake into his heart.
THE SETS BEGIN TO FALL

End of exert

Because our budget

was 0$, the

sets that
were to fall,
where not secured
well and so didn't
fall on que.
But,

A bit before Van
Helsing made it to
the Dracula, who
was just ready to
be stabbed, on que,

*SETS FALL
EARLY*

almost falling badly,
but, mostly missing
the players. But

HELSING Fell...

Marco who played
Seward, a doctor, who
was nearby, thought
to himself; "Dracula
has to die. And,
Van Helsing is down
because of falling set.

So I will take
care of business,
the business of making
sure he dies."
So he grabs the
stake from Van Helsing
and runs to Dracula.

Van Helsing (Maureen)
who is getting up,
too late, realizes
that now....

'the whole'

She had meticulously
worked at to prepare
for her right,
Van Helsing's right,
 to Stab.......
Now Marco, as Dr Seward,
not Maureen as Helsing,

NO NO NO

But Yes! Yes! Yes!
You might say; "What's it matter?"

MAUREEN IN A BIGE MOVIE 2015
'now the whole that she had meticulously worked at to prepare for her right...
Van Helsing's right to stab'

Ah, but here's the
RUB.......
It matters if it
matters.
And it matters if
you know a story.
And,
and this is
a big and beautiful,
And, and if you play
a character …. your
character has a path….
It must take a destiny.

This destiny is crucial for…
Well, it's hyper important!
Not just because a story
is a story, but because
a character's existence
must matter!

If you are Van Helsing
you must finish your whole
purpose in life. You must do the
job or

you are forever
left unsatisfied.

STUDENT RAW ART
'You must finish Your whole purpose in
life. You must do the job….'

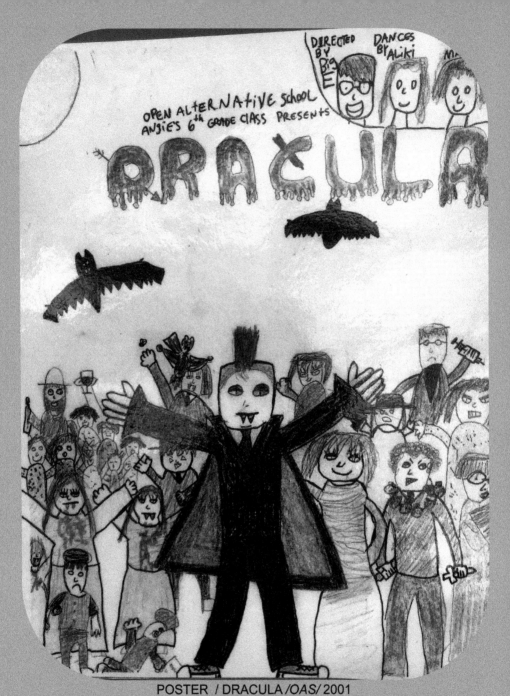

POSTER / DRACULA /OAS/ 2001

'the beauty of good actors… and good theater … you care about the pretend world … It matters so much'

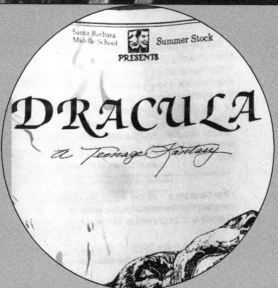

Santa Barbara
Middle School
PRESENTS
Summer Stock

DRACULA
A Teenage Fantasy

SOMETHING, SOMETHING ELSE. *{1993 – OLIVER}*

WIZARD OF OZ – MARCO FLYING MONKEY – 2003

'Where do I go… Follow the river… Where do I go …. Follow the stream'

The count down.
Four 3 2 1 here we go.
Blast off! To where?

Where do I go?
Follow the river.
Where do I go?
Follow the stream.
There is no difference

Where do I go?
Follow the river.
Where do I go?
Follow the stream.
There is no difference

STUDENT RAW ART
'The count down. Four 3 2 1. here we go. Blast off!
To where?'

Hair (musical) Wikipedia

Hair: The American Tribal Love-Rock Musical is a rock musical with a book and lyrics by ... I set it to music." MacDermot wrote the first score in three weeks, starting with the songs "I Got Life", "Ain't Got No", "Where **Do I Go**" and the title song.

Where do I go
Follow the river
Where do I go
Follow the gulls
Where is the something
Where is the someone
That tells me why I live
and die
Where do I go
Follow the children
Where do I go
Follow their smiles
Is there an answer
In their sweet faces
That tells me why I live
and die

SEEING THE MUSICAL HAIR IN 1971 AT
THE AQUARIUS THEATER IN LA
INFLUENCED MY PERCEPTION OF
THEATER SIGNIFICANTLY –
Anything and everything is allowed.

If only this one thing could sink in.
Playful as it sounds,
OH YES, Playful.

Let's talk about all!

That's what you're here for, a lesson of show time.

Which show do I tell you about?
THE ONE, OLIVER.
My tried and true, Gretchen, assistant director, and also a student. She was 15 years old.

last day….

Things were blasting off.

That night the show was going
on stage in front of people
for the first time!

Oh my golly gosh
time was of the essence.

Up runs my tried and true assistant.

Gretchen helping
'Things were blasting off That night the show was going On stage in front of people for the first time'

"Do you know what you've done?????" Do

you have a clue of the disaster you have perpetuated

Night coming soooN sooNER THAN CAN BE BELIEVED It was Not Crawling iNTo LIFE IT WAS goNNA BLAST OFF.. The SHOw

WAS goNNA BLAST OFF IN 2 HOURS or so.

And, as I

hurriedly exited

the dark specialized

light of the theater,

"Where is she???

SHE is Suppozed To BE ON STAGE!!!

THERE SHE wAs crying iN a corNer oF THE Hall

With her friends who were sitting with her. **And, time was running** They too needed to be performing, **out!!!**

STUDENT RAW ART

148 "I always thought that what we were doing was never going to be really real"

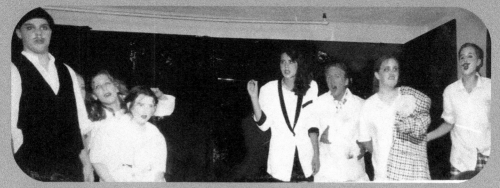

MERMAIDS TALE - 1992
'I would have to pull a slight of hand'

gonna be too long since I had to give EVERY one And I mean EVEyon good LINES

I would have to pull a slight of hand.

I would ……..

The show was destined to be Fake And therefore No good I would Have to trick the Audience !!

Oh yeees, trick the audience!
Big Trick!!!!

Picture this.

Fagin's Ride
pulls into parking lot.

Artful Dodger
jumps out of the car,
and opens door
for his, *Fagin*,
his notorious boss
who runs a gang of
child thieves.

Audience

has moved

Into the

parking lot.

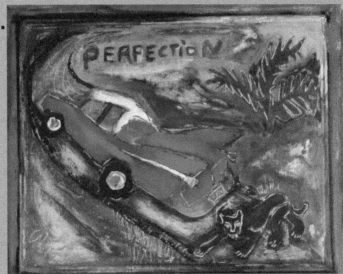

ORIGINAL PAINTING BY ERIC LEHMAN – 2016-
"Picture this - Fagin's Ride pulls into the parking lot"

As Fagin gets
interviewed by news
reporters:
"Excuse me Mr. Fagin is
it true you run a band of
child thieves?" Fagin
and his cohorts
push through the
theater door
shouting out;

"No comment! NO comment!"

Later, outside for the

conclusion.

In a cacophony of inaudible but precise shouting……
the audience takes it seriously because we made them….

seriously

….get out of their seats….
…. again

"Move to an outdoor

balcony and staircase."

We see yelling and mayhem

as Bill Sykes falls off a balcony, down the stairway,

to an

inglorious death.

in·glo·ri·ous

1. (of an action or situation) causing shame or a loss of honor.

STUDENT RAW ART

'Bill Sykes falling off a
balcony down the
stairway to an inglorious
death. The audience
takes it seriously
because we made them
seriously get out of their
seats……. again.'

THE END OF AN ERA....THE END OF MY LIFE AS I KNOW. OR SHOULD I SAY THE END OF ME, AND WHAT I HAD KNOWN.

{1993 - JEANNE - JUNGLE BOOK - BEAST}-

THE END OF AN ERA….
THE END OF MY LIFE AS
I KNOW. OR SHOULD I
SAY THE END OF ME AND
WHAT I HAD KNOWN.

Don't get me started
on telling you made
up stories which is
what I always did
at the time.

What my mom
always said kids
is this;

"If you want
the audience
to hear you don't
shout, don't make
every line perfect,
say what you mean."

"Wise guy speak

as a rascal might.

A brainy genius,

speak as if you

know everything.
Don't shy away
from the truth
set it free"

And….. "It starts
from inside,
inside your
self. If you act

from there you will

be heard"

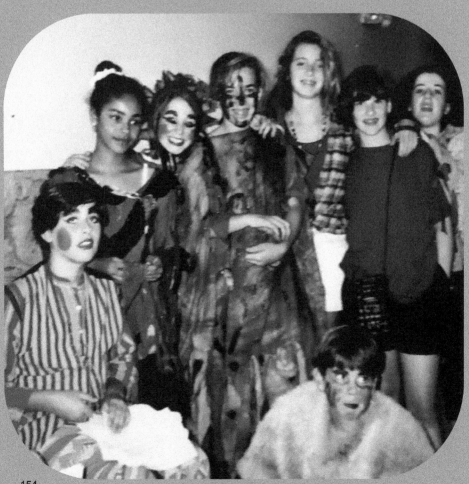

154

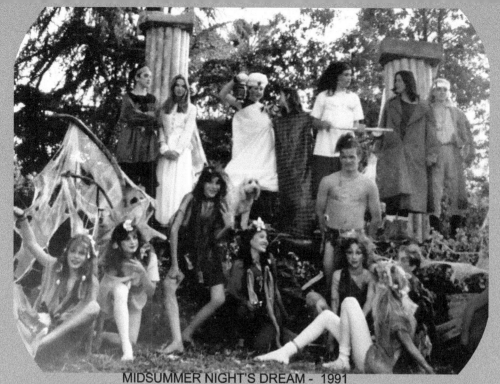

MIDSUMMER NIGHT'S DREAM - 1991

'Don't shy away from the truth Set it free And it starts from inside yourself. '

Everyone knows the truth…….. Problem is, it wasn't the truth. Mom never said that….. exactly …. I told many many many

'what my mom always said' stories.

In fact it would start like this;

"You want to know what my mom would say?"

"Yes what would she say?"

"Well to start with, never go over there or over there unless over there is where you need to be. Random moves makes me crazy"

Again, she never said that.

BEAUTY AND THE BEAST - 1993

'Everyone knows the truth…….. Problem is it wasn't the truth Mom never said that Exactly …'.'

Perseus – 2010

'want to know what my mom would say'

BEAST POSTER BY BEN HAZARD -1993-
'We started rehearsing Beauty and the Beast which we called – Beast'

"Well to start with, never go over there or over there unless over there is where you need to be. Random moves makes me crazy"

Again, she never said that.

Beauty and the Beast which we called –

Beast

As the title of the show.

We were performing at a venue in town,

. We were going Big, lots of kids, lots of adults. I was Beauty's Father Panzar.

PANZAR: I'm Maharaja Panzar, the father of this family. Things aren't going well. I can't get anyone else what they wanted; I might as well get Beauty her request. How fitting, she who wanted nothing gets her simple wish. (picks rose)
Beast storms on.

Maureen was the crazy Claudia.

The Center

Stage

Theater

CLAUDIA: No! No! No! NO! NO! Panzar and his awful family are coming here.. . My space is being invaded! MY HEAD!! The pain in my head like two arrows of fire

took place in Persia,

Big turbans

and All.

BEAUTY AND THE
BEAST – HAKIM -
2008
"We were going big lots
of kids, lots of adults."

JUNGLE
BOOK
POSTER BY
AMY HAZARD
"A session in the
morning for little
kids
And one in the
afternoon for
older youths"

In the morning we
were doing

Jungle Book with

the younger kids.
Remember…..

Only 4 days a week.

Oh the drama,
the joyful hilarity
of time …. Tick tick
ticking away
so so so beautiful.

Marco, my deep
and wonderful
friend who later,

was the first to
start clapping as
he looked over at
the door.

Santa Barbara Summer Stock
Junior Troop Presents

Jungle Book

'was the first to start clapping as he looked over at the door'

as I stopped FOR A SECOND FROM REHEARSING JUNGLE book and seeing my mom ENTER I shouted "Hi mom!"

Marco clapped. Every one in the rehearsal space began clapping and cheering.

Because she was the lady who.......

Said so many wise words LiKE JUST a FEW MINUTES EARLIER

Ya want to know what my mom always said?

WHAT.?

you look mad and talk all the time about it

Wellllll anyways, In walks mom, with everyone cheering and applauding.

YOU LiKE will FEEL ugly and BORing...

Well, you can
just imagine what
was going on in
my mom's head as
she walked into
have a quiet word
with me about
dropping of the car.

She was clueless.
She didn't know
any of these people.

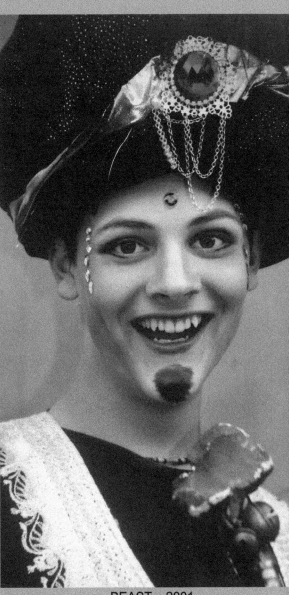

BEAST – 2001
'She was clueless. She didn't know any
of these people.'

How did they know HER – SHE WAS PERPLEXED to say The LEAST....

What happened next
is best left to the
imagination. But I
will say she was
appreciated and she
felt loved.... and
very confused.

So much rehearsal
had to be done
because there were
two casts.
And so much prep work,
so much prep work,
so much prep.
I had
worked days on the
script's changes.
Changes
on lines and scenes
so it would be
better and better.

A clean mean running machine.

....I was truly the only person
who knew.... really,

MOM
'But I will say she was appreciated and she felt loved
and very confused.'

BEAUTY: I'm certainly glad that money is making you happy, but I can't help but feel a sense of foreboding about it. Money does not bring true happiness. I get more joy looking at a rose than having all the riches in the world.

SOCORRO: Its you! You're the one I've been looking for. You say a rose... (smells the air for a sign) Yes... that what you should ask for. Ask for a rose. That will do just fine.

BEAUTY: A rose then.

ASMIN: A ROSE!!! OH FOR GODS SAKE BEAUTY!!!! →add LAZLO TO CLAUDIA

[All start talking then FREEZE except Panzar.]

PANZAR: Maharani Ramos has told me that my ship has come in. (pause) You know, (looking at Ramos) she's one hot looking gal. She seems to have plenty of money. Good looks and money, all the things that make a perfect wife. Now I must convince her I'm the perfect husband. (talking to Ramos) I had to come out here to our little country cottage when the fire broke out... (making reference to Aloba and Claudia) They are our servants... but I treat them like family. (FREEZE) ~~Claudia the place~~

RAMOS: Maharaja Panzar is good looking and has money. The perfect ingredients for a perfect husband. (to Panzar) Yes I wish you would come and join me and my children Hakim and Gilda at my little apartment in the city where we can conclude our business...We're living in the city because my castle on the coast is being remodeled...

[End of Scene 2]

Handwritten:
Lazlo: you can't hide your feelings any more I know
Claudia: know what?
Lazlo: the fainting the shrieks of joy It's me
Claudia: you?
Lazlo: your desire to be alone -- why to be with me
ofcourse
Claudia shriek
Lazlo: ahh
Claudia: shriek
Lazlo: ahh baby give me what I want

Handwritten top margin: Stevi Laiou feelings I just want my space

Handwritten box (top right): REALLY THIS IS NO made up mom story ONLY BIG E and that's me KNEW The ins and outs OF The BREAKING

play......Actors knew what was
expected of them.
But
It was I, me, myself,
who could tell our
tech man, that day,
at the theater, the
day before the show.

I had just rewritten it.
I had the script.

LQ-Gobos and center spot up

Beast alone on stage dying.
BEAST STAGGERS
BEAST: The pain of this farewell night...
The lost glory of love will remain woven in my visions.
Open with your own hands the door towards final
separation.

BEAUTY: (enters) I shut my eyes and see in my heart the beauty that is beyond all forms.
Beast falls to the ground

Handwritten: I KNEW what was written and ME I myself was The one and only man for The job... It was all up hear in my head

up here in my head.
I was the one who
knew the changes.
And, in fact I had
written the play
adinfinitum.
ad in·fi·ni·tum
again and again
Of course......

Handwritten: maureen was The real story TELLER

BEAUTY: (realizing he's dyeing) BEAST!!! No! NOOO! You can't die! I love you! I want to marry you!!

FXQ-38 BEAST EFFECT / FXQ 39 SMOKE
Beast is transformed to his original aspect.
LQ-GOBOS OFF / LQ-BEAST CASTLELIGHTING
 BEAUTY: I want my beast.
Beauty walks away from Beast.
BEAST: I am he.
After a moment Beauty turns takes Beast's hand he
picks her up looks over his shoulder and Growls very loud.
LQ-BLACK OUT

When I say I wrote
I mean organized
it on paper so
we had scripts.
And, as is my ways,
I constantly added
jokes and silliness
from the actors.

So… here it
is dinner time.

We have hours left to go.
But need to take a break.

And low and behold….
there is my Brother Don,
and his wife,
my sister in law,
Laurie.

alive mother
had died a couple hours
earlier having drinks
with her neighbor.
And no they
weren't drunk
or anything like that.

Maureen thought of using Rabindranath Tagore's poetry in the script

that we are different
My mind refuses to own it.
For we two woke up in the same sleepless night
While the birds sang,
And the same spell of the spring
Entered our hearts.

Though your face is towards the light
And mine in the shade

The delight of our meeting is sweet

And from there I must say

…….And

EEIRIE SORT OF NOTHINGLES ENVELOPE ME AS MY BROTER TOLD ME MY VERY

She had a blood clot
that went from her
broken leg to her
heart.

This is the truth;

She did always
say when she
was very happy…

"IF Im going to
DIE LET it BE
Now"
and SHE did DIE
Add SHE Probably was
very Happy…

And here is
where a very bitter
not so sweet,
The Show Must
Go On,
must be inserted.
Because, Beast,
(Beauty and the Beast)
and Jungle Book
both went onto the
stage that weekend.

I did finish the lights that night with the help of my very loved and very trustworthy Rainsong who was my stage manager,

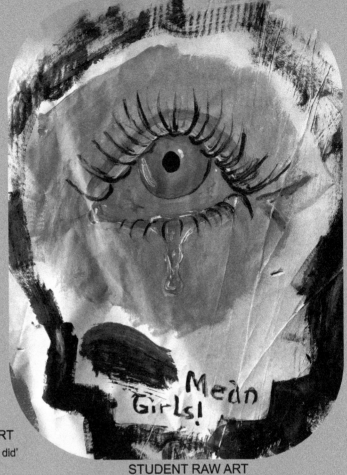

STUDENT RAW ART
'cry I did, act I did, cry I did'

STUDENT RAW ART
'I did finish the lights that night With the help '

And my **3** wonderful stage crew boys.
Cry I did…..
Act I did….
Cry I did…..
Maureen took good care of me of course during that time.

And, I will never forget or maybe I should say never forgive Marco…..
Last rehearsal of Jungle Book with the little kids… They all knew their parts

and their lines.

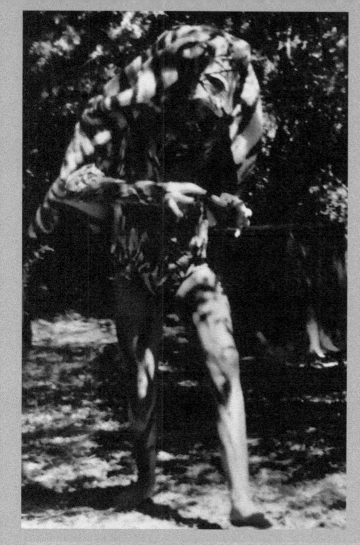

Marco
played
the bear
Baloo
who was
best
friends

With THE Boy who
would TAKE my
SNaLing charachter
down and staß
me with a KNiFE

And sure enough
 it happened right
on que.
The rehearsal
was
almost over.

EVERY Thing was running zmothly, Hll Marao

As Baloo, **shouted!**

Just after I, the tiger, was stabbed.
And I died an ignominious
ig·no·min·i·ous
deserving disgrace or shame.
"no other party risked ignominious
defeat"
ignominious death.

Jungle Book
-1984- Mogli
and the
Banderlog
'the wildling that
lived in the jungle
and was raised by
the wolves'

Silence
as only the silence
of death can hold.

Then, Baloo, that
big lumbering bear
shouts

"FEED ON HIM"

And as one the
whole cast
of wolves, panthers,
leopards, even the
monkeys.....

jump,

literally

jumped

on me,

and about

me, in a

painting by Eric Lehman
'Poor helpless 35 year old BigE..'

wild frenzy of pretend. Eating
off poor Eric.....
Poor helpless 35 year old

BigE..
Oh well
C'est la vie

C'EST LA VIE DICTIONARY
LIFE'S A BITCH · SHIT HAPPENS
· THAT'S LIFE · THIS IS THE LIFE.

AS I LEAVE

{2017 – ALEJANDRO THE POLICEMAN}

Junk Art Room Wall
"The subtlety of decisions made"

AS I LEAVE for a bike trip with the
school I work at,

For instance

Dracula - 2000
"start the process by choosing"

, how to make mankind better.

Let's start the process
by choosing to collect
a series of individuals
to play a myriad of parts,
that in the end,
a whole shitload of people
will witness.

Do I have a witness here?

"y Yes, I saw the show!"

"Well?? What did you think of it?"

"I just want to know why…..
why….
when your people….
your actors are obviously just feathers
in the wind…
they aren't that good."

I cannot help but reflect…

On What?

How much sensitivity it takes.
The subtlety of decisions made.
What you have to live with.
How many stories go down the way,
but you still live with them your whole
life.

Dracula - 2000
"start the process by choosing"

"Yea maybe,
just maybe, you should have stuck around for the end.

KID'S ART
"His one line (the one that was all his)"

And, shown up at the beginning….
Like maybe….

t one and only precious soul.

We were doing the show
Mr. Popper's Penguins.

d, this little soul,

ejandro,

s a policeman,

ears old.

one line (the one that was all his),

other police and Alejandro said some lines in

son,

...... his line was, when his

aracter was forced to put the

nguins in jail;

XERT FROM SCRIPT
CT I SCENE 5 POPPERS PENGUINS GET ARRESTED

ENGUINS AND POPPERS TRAVEL ACROSS IN THEIR TOURING
USS FINALLY ENDING UP IN NEW YORK.

WENSON: LADIES AND GENTLEMEN! WELCOME TO THE
EW YORK REGAL THEATER! TONIGHT WE ARE PROUD TO
RESENT THOSE OH SO FAMOUS, SWENSON SEALS!

DALINA: NOT KNOWING WE WERE IN THE WRONG THEATER

ENNY: WE BEGAN OUR ACT.

OUISA: ONLY TO BE MET

ICTORIA: BY THE SEALS

SWENSON: HOLD THOSE PENGUINS!
 I HAVE A WARRANT FOR THEIR ARREST.

POPPER: WHAT HAVE THEY DONE?

SWENSON: THEY'VE BROKEN INTO MY THEATER AND
THROWN THE PLACE INTO A PANIC, THAT'S WHAT THEY'VE
DONE. A DISTURBER OF THE PEACE.

POPPER: BUT I'M MR. POPPER, AND THESE ARE MY
PERFORMING PENGUINS, FAMOUS FROM COAST TO COAST.

SWENSON: I DON'T CARE WHO YOU ARE, YOU HAVEN'T ANY
BUSINESS IN MY THEATER!

POPPER: BUT MR. GREENBAUM IS GOING TO PAY US FIVE
THOUSAND DOLLARS FOR A WEEK AT THE REGAL.

SWENSON: MR. GREENBAUM'S THEATER IS THE ROYAL, NOT
THE REGAL. YOU'VE COME TO THE WRONG THEATER.
ANYWAY, OUT YOU GO, YOU AND YOUR PERFORMING

POLICE BEGIN TO TAKE PENGUINS AWAY
IR POPPERS KIDS BEGIN TO CRY.]

ND ALEJANDRO SAID; (THE 7 YEAR OLD POLICEMAN)

POLICEMAN (SHAKING HEAD): TIS A SORRY BUSINESS, TO BE MAKING
CHILDREN CRY.

END OF EXERT

Oh the joy I felt every time Alejandro would say that line when it got to his part during rehearsal,

KID'S ART – Poppers Penguins
"when it got to his part"

hat Maureen and I.......
Maureen was also captivated)
Well it was like everything

would stop.

Almost as though everyone was

holding their breath.

As the time came,
his que.....
kids started to cry"

pause.....

he great pause as all eyes fell on 7 year old Alejandro.
His first show.
His first big line.
ll eyes on him,
s he looked around for a second.....
s though he was looking deep inside himself to find his words that would complete his job in the play.

he would call all forces
to deliver this proclamation!
There he was,
you could see Alejandro was ready.

nd rehearsal after rehearsal it was the same,

KID'S ART – Poppers Penguins
"he would call all forces"

And, out come the

he pause.

words,

175

ll ears perked..... for his line as,

one at a time.

POLICEMAN (shaking
ead): Tis a sorry
usiness, to be
aking children cry.

nd after, that little kid was
nished, it was as though we,
Maureen and I, had just been
witness to a declaration,
o, a full-on thrill of all thrills!

I Joke you NOT
WE FELT THRILL

So deep. Oh God!!!! Thankyou
So lovely.
So sweet.

It sounds unreal,
Impossible.

But it happened,
and we get it!

We don't forget that moment,

and I cry just knowing it's mine.

KID'S ART – POPPERS PENGUINS

'So deep So lovely So sweet'

KIDS THANKYOU NOTE– –

'We doin't forget that moment, and I cry just knowing it's mine.'

NOTHING I LIKE BETTER

{2010 – MAN OF LA MANCHA}

NOTHING LIKE BETTER

then when I look into your eyes,
my little friend….
I look into ….
to your eyes and I say……
I say to you boy or girl,
because either can play
this marvelous man….
This dreamer,
a man of such high ideals.

I say to you
cry, cry for a world
where your sweetest,

most innocent of innocents,
are in danger.
Yes, in mortal danger.
Their souls can go by the way
if you don't call them
back from oblivion.

Myth Of Perseus - 2004 -Perseus
"I look into your eyes"

Something that moves you
to the brink of passion….,

Trust that passion.
Let the passion drive you
into oblivion ….
The passion that drives you.

Shouting
at the top of your lungs;

Beauty and the Beast - 2006
'Call them back from oblivion'

Maureen and Amanda singing at the Soho –
1997

"Let The Passion Drive You Into Oblivion"

"Believe. Oh yes
believe"

DREAM! DREAM!

Myth of Perseus
-Greek Gods -
"This is no
Joke"

Don't hesitate.
Don't think.
Don't give up.

Move!

March! **Charge forward!**

Dracula –1998- Renfield
"Don't hesitate, Don't think, Don't give
up."

Junk Art Room
'Wake Up! It Is Real'

hen pause,

Pause.......

Pause as all good actors do…

And beg, on your knees

wake up!

t is real!!!!

The flowers… the smell of the flower, that exquisite smell……

"I am the Lorax and I stand for the

trees"!

Those poor Truffula
Trees
getting cut down
made into….

Things of value…

Ah please …

The Man Of La Mancha
Is on his death bed.

Painting by Maureen Lehman
"I am the Lorax and I stand for the trees!"

STUDENT RAW ART
"win or lose if you follow the inner call"

the lady most spectacular.
She whispers to the dying hero of the story, who, fell from his dreams when he encountered the Night of Mirrors, and, was convinced he was a fool.

Aldonza whispers;

ALDO NZA: Please! Try to remember!

An excerpt from

I, Don Quixote

A play by DALE WASSERMAN

DON QUIX OTE (with helpless compassion): Is it so important?

ALDONZA (anguished): Everything. My whole life. You spoke to me and it was different.

DON QUIXOTE: I...spoke to you?

ALDONZA: And you looked at me! And you didn't see me as I was! (Incoherently:) You said I was...sacred, and lovely. You said I was a...a vision of purity, and a radiance that would light your path. You said a woman is glory!

DON QUIXOTE: Glory...

ALDONZA: And you called me by another name!

DR. CARRASCO: I'm afraid I must insist—

DON QUIXOTE: Leave her be! (Deeply disturbed, his mind stirring.) Then perhaps...it was not a dream...

ALDONZA: You spoke of a dream. And about the inner call. How you must fight and it doesn't matter whether you win or lose if you follow the inner call. And our mission!

DON QUIXOTE (with growing alertness): Mission?

DON QUIXO TE: The words. Tell me the words!

ALDONZA (her eyes shining): "To dream the impossible dream. To fight the unbeatable
e. And never to stop dreaming or fighting...!"

DN QUIXOTE: "This is man 's privilege—and the only life worth living."

End of exert

Now my friend,

This **This** **This**

is the moment
where you truly act.
That moment between
unbelief... depression...
weakness.. defeat,
to a delicate transformation.

The voice of your
true friends
Aldonza and Sancho
call forth from you
a glimmer at first...
of a memory,
a far remnant
of a thought,
no a belief,
a mission.

A mission to stand for
something,
something true and good to believe in.

The Impossible Dream. **Exert from script**

DON QUIX OTE: (HE turns to her, his eyes catching fire.) Dulcinea! But this is not seemly, my lady. On
thy knees? To me? (HE gets up, raising her.)

ALDONZA (in protest): My lord, you are not well!

DON QUIXOTE (growing in power): Not well? What is sickness to the body of a knight-errant? What
matter wounds? For each time he falls he shall rise again—and woe to the wicked! (A lusty bellow:)
Sancho!

SANCHO : Here, Your Grace!

DON QUIXOTE: My armor! My sword!

SANCHO (delighted, claps his hands):
 More misadventures!

Man of La Mancha – 2010
"let the good take heart and
the evil beware"

ALDONZA (a cry of apprehension): My lord...!

DON QUIXOTE (in a whisper): To the stars! (The sword falls from his hand and HE crumples to the floor.)

Nothing like a bittersweet death, in the world of pretend,

it makes life glorious!

Man of La Mancha -2004
'Cry, quake, gnash thy teeth— it will avail thee not. He shall win!'

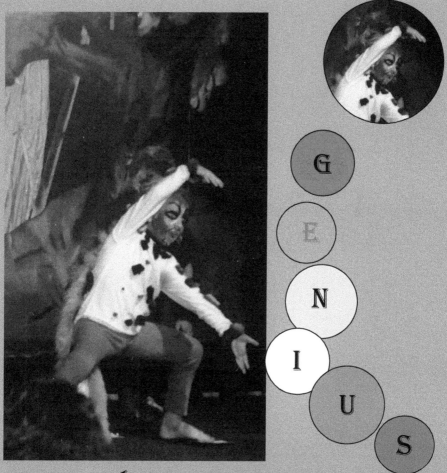

G
E
N
I
U
S

BUT.... WHAT MASTERFUL GENIUS

BUT…. WHAT MASTERFUL
GENIUS,
this wonder of wonder,
Power to direct, originates
from?

FANTASY
MAKING FANTISY
REAL FOR A
MOMENT REAL
FOR YO TO SEE
AND THEN who TAKES
PLAY TIME AWAY
FROM THE COMMON
MAN
WHY did ~~$a~~ DAN
AND I CLIMB a
TREE ONE day
and d whisper

whisper !!
IN a TREE?
WHY?
you were 12
years old FOR
gods SAKE
WHAT WERE
you whispering
aBouT PROBLY
SEX Right

NO!

We confided in each
other......

That

We both

STILL LIKED TO
PRETEND TO BE
SUPER HEROS

Superman
and Batman
ruled!

And in my
comic.......

Superboy
kissed Lana
Lang!

True
romance!

EP

IF EVER

LEAV

WOULD

YOU

STUDENT RAW
ART BY A 14 YEAR
OLD GIRL 2018

IF EVER I WOULD LEAVE You....
Would I ever leave you....
Why would I ever leave you
The way you are is such a glorious
way
The return is....
What I get from you....
OH my dear I love you so....

AHHHHHHHH**H**

ART

To put it simply

STUDENT RAW ART

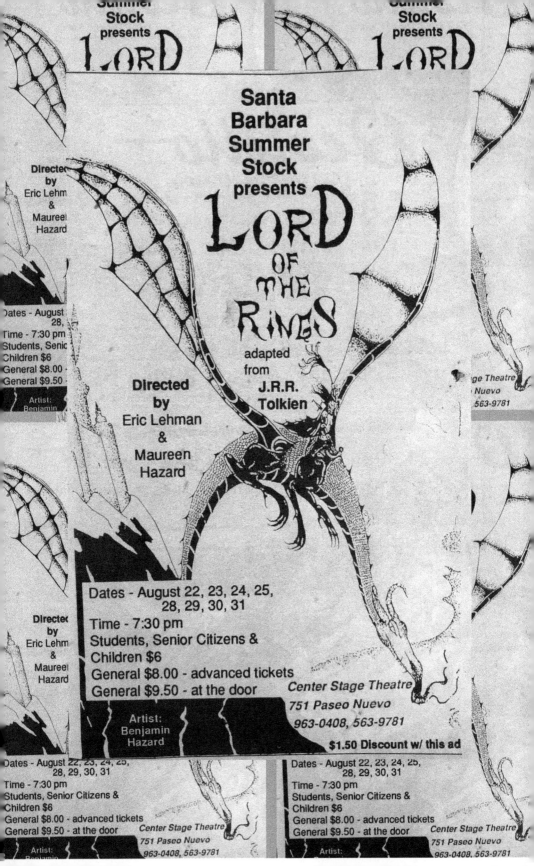

Santa Barbara Summer Stock presents

LORD OF THE RINGS

adapted from J.R.R. Tolkien

Directed by Eric Lehman & Maureen Hazard

Dates - August 22, 23, 24, 25, 28, 29, 30, 31

Time - 7:30 pm

Students, Senior Citizens & Children $6

General $8.00 - advanced tickets

General $9.50 - at the door

Artist: Benjamin Hazard

Center Stage Theatre
751 Paseo Nuevo
963-0408, 563-9781

$1.50 Discount w/ this ad

The Mermaids Tale

LOTUS THEATER 4 TO 5
MONDAYS AND WEDNESDAYS

The Tales of Arabian Nights

OAS - 1990's

By:
Marissa Sandoval

Frankenstein Jr
1996

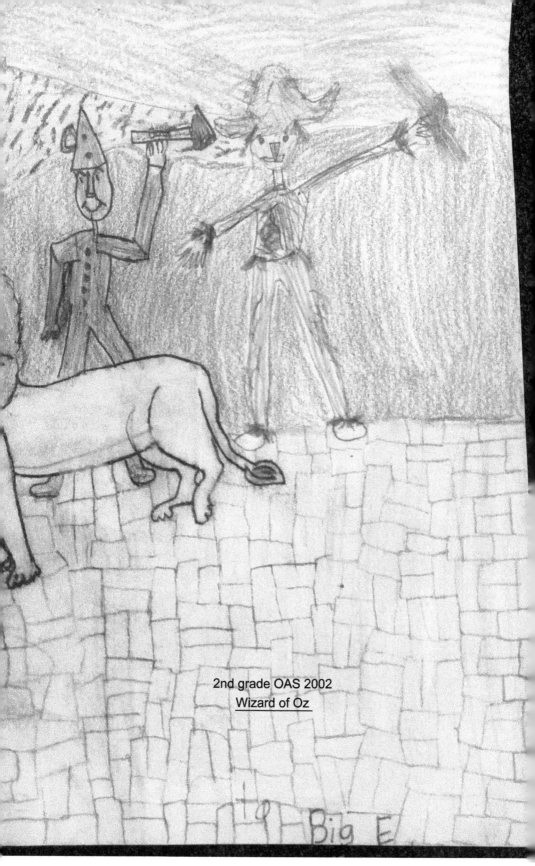

2nd grade OAS 2002
Wizard of Oz

Big E

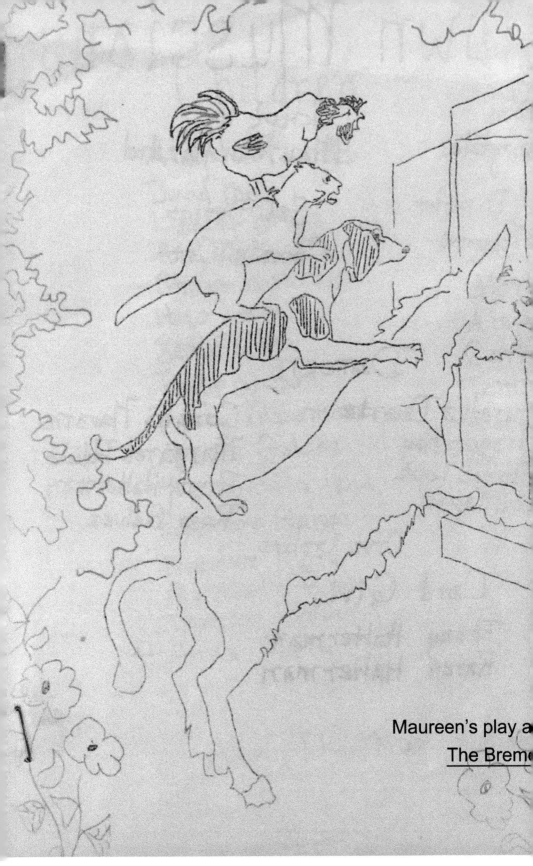

Maureen's play a
The Breme

Vista Del Mar

presents

The Bremen Town musicians

e la Cruze -1974

Musicians

Destry Rides Again

Dracula

East Of The Sun West Of The Moon

Everyone Knows What A Dragon Looks Like

Fiddler on the Roof

Fractured Fairy Tales

Girl On A Rock

Hobbit

Jack And The Beanstalk

Jungle Book

Lady and the Tramp

Legend

Lion King

SANTA BARBARA SUMMER STOCK

PRESENTS

BEAST

July 21st - July 31st
Center Stage Theatre

1997 Beauty and the Beast
Art by Ben Hazard

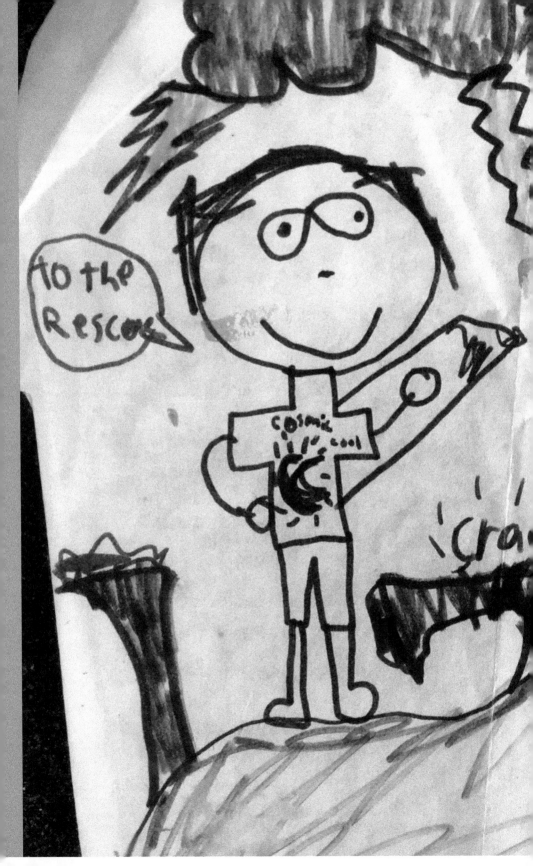

to Big E
and the
Cosmic
Sky

2011 - The Cosmic Cools

Lion the Witch and the Wardrobe
Little Red Riding Hood
Lorax
Man of Lamancha

Mermaid's Tale
Moor's Legacy/ Tresure of the Sierra Madre
Oliver Twist
One Flew Over The Cuckoo's Nest

Perseus
Pinocchio
Popper's Penguins
Raggidy Ann and Andy Go To The Moon
Scrooge

Sea Horse Cafe
Snow White and The Seven Dwarves
Tin Tin in New Orleans
Treasure Island

Dena's 2nd and 3rd grade class
presents

Snow White

Directed by:

Big E and Maureen

April 17th, 2002

OAS - 2002

Legend

Santa Bar

Santa Barbara Summer Stock
1999

Summer Stock 1999

Tribes
Star Wars
Watership Down

1993

1999

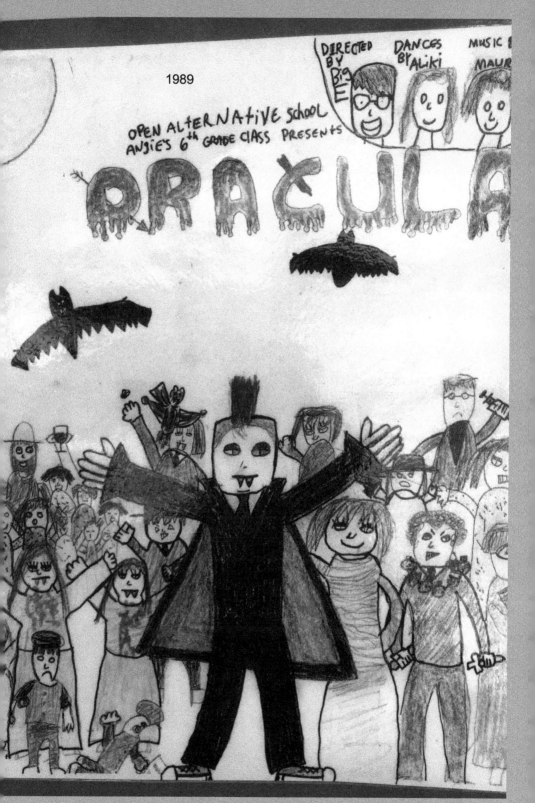

poster by Amy Hazard 2000

Wizard of Oz
Performed 19 times

Lion King
Performed 7 times

The Myth of Perseus
Performed 12 times

Santa Barbara Summer Stock
in conjunction with SBMS
presents "The Myth of Perseus"

Ages: 6 to 14
June 17 through July 14
Monday through Thursday
9 am - 1:30 pm

Cost: $675 for all 4 weeks.
Snacks (but not lunch) are provided.

Questions? Call Eric Lehman at 805-698-8920.
To sign up, email SummerCamp@sbms.org.

shows at 7:00 Show sun.

shows
Thurs
JULY 11 eve.
JULY 12 eve.
JULY 13
Matinee
and
evening
7:00
evening

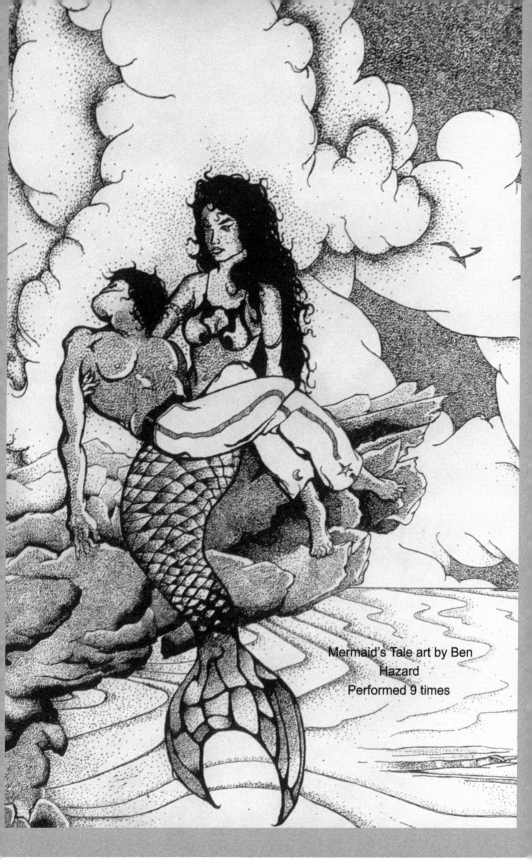

Mermaid's Tale art by Ben
Hazard
Performed 9 times

New Production

☆☆☆☆

BES

25.30.31

8:00 PM

Santa Barbara Summer Stock presents July 28 & 29

The Wind in the Willows

The Wind in the Willows
Performed once

Santa Barbara Middle School
Drama Department
presents

presents

Snow White

Directed by:
Peg B and Maureen

April 17th 2002

The Myth of Per...

Ages: 6 to 14
June 17 through July 14
Monday through Thursday
9 am - 1:30 pm

Cost: $675 for all 4 weeks,
cks (but not lunch) are provided.

presents
July 28 &29

e Vind in th

Sain
Summer Stock

A New Production
☆☆☆☆

Original
Theatre!

TRIBES

GUST 24,25,30,31
8:00

Spaulding Theater
Laguna Blanca School

The Mermaids Tale

THEATER

227

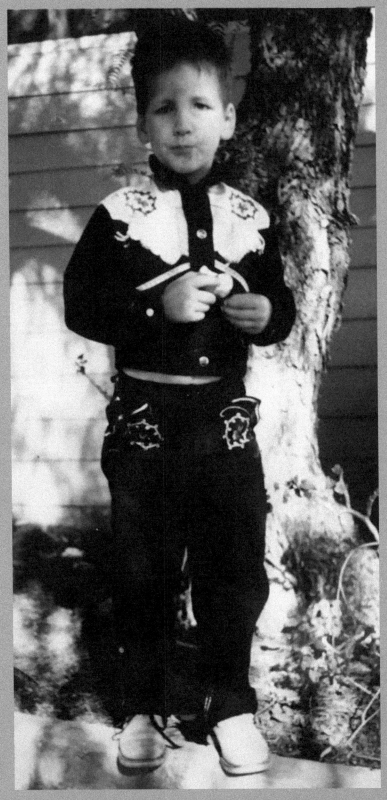

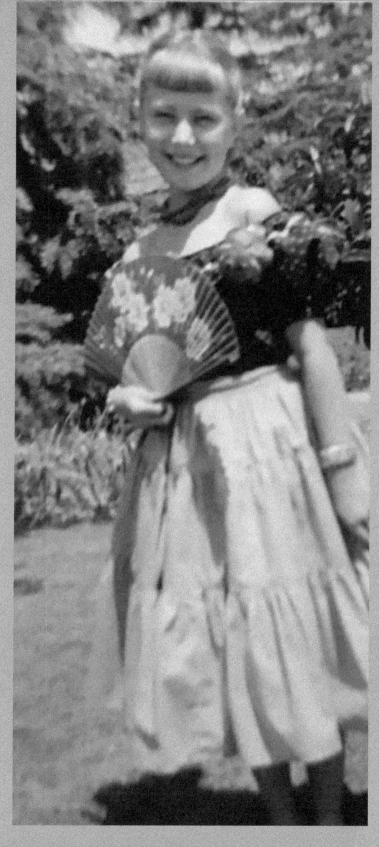

With Gratitude-

Without help I never in a million years would ever have been able to accomplish the adventurous task of writing and publishing the story of my life in youth theater.

But who more do I have to thank than Peter James Ljung. How do I tell you the stupendous giving that has come from this gentleman. A gift from the heart, oh yes, but more. A man willing to go above and beyond what most people would ever consider when it comes to selfless service. Not so long ago, Peter himself a published author of a series of different titles from auto biographies to romance and adventure, offered to publish my auto biography, asking for nothing in return.

We had spent some time in an online meeting getting to know one another. Him in Sweden me in California. I spoke to him of my work that was finished, Teenage Mutant Theater. He texted me; 'I am going to publish your book for you.'

The rest is history. All I can say is without him I would no doubt still be struggling with the complexities of what to do. Thank you Peter.

I also want to thank my wife Maureen Lehman an artist, musician and theater arts producer and director

who has been a constant support in the last two years. Having her at my side with her suggestions and perspective have proven invaluable.
Much thanks to my daughter Kyra Lehman and her partner Jake Himovitz for their constant support and willingness to peruse the written chapters as they developed piece by piece by piece.

Thanks to Danielle Monroy and the many other costumers for your exquisite work over the years dressing the actors .

Thanks to Amy Hazard and the myriad of makeup artists that joined in on the fun for so many shows.

Thank you Richard Wilke for the wonderful sets you have created for us from 1986 through to the present.

A huge shout out to the artist's young and old who created the art and shot the photos collected in the past 4 decades.

Thank you Maryann and Freddy Caston and Robin Lehman for helping create our summer theater program Santa Barbara Summer Stock.

A very special appreciation goes to Cristine Adcock, a Clay and Fiber Artist, who with no request for compensation has taken exquisite photographs of the shows that Maureen and I have produced, many of

which are in the book.

And finally I want to thank the actors, and their families for joining us in the wonderous adventure of performance art.

Sincerely Eric Lehman

Perhaps added somewhere.

Eric with his wife Maureen and their 5 kids and 9 grandkids have all participated in the shows over the years.

Big

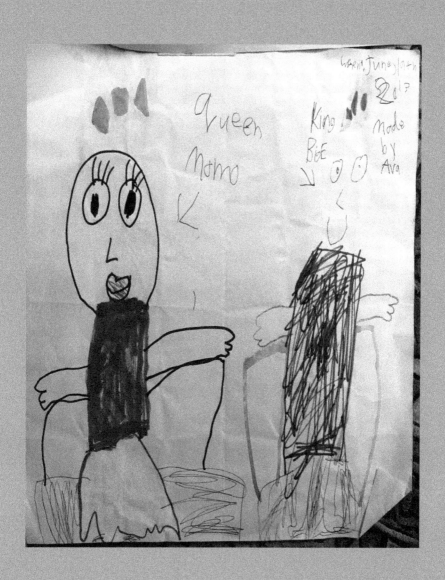

235

LOVELY

you r so

LOVELY

thats all

folks

Lightning Source UK Ltd.
Milton Keynes UK
UKHW020006270420
362252UK00009B/132